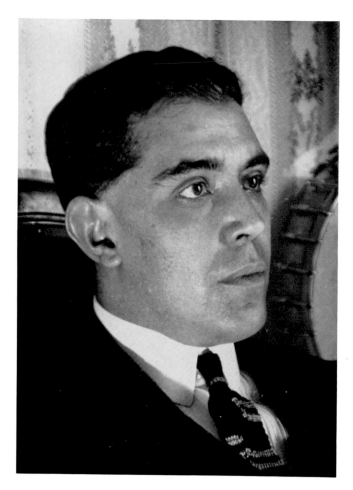

Juan Gris. Photo by Man Ray, 1922

Juan Gris

by James Thrall Soby

The Museum of Modern Art, New York

in collaboration with The Minneapolis Institute of Arts

San Francisco Museum of Art

Los Angeles County Museum

Published by the Museum of Modern Art, New York, 1958
All rights reserved
Library of Congress Catalog Card Number 58-8632
Printed by W. S. Cowell Limited, Ipswich, England

LENDERS TO THE EXHIBITION

Mr. and Mrs. Armand P. Bartos, New York; Heinz Berggruen, Paris; Mr. and Mrs. William Bernoudy, St. Louis, Missouri; Mr. and Mrs. Leigh B. Block, Chicago; Mr. and Mrs. Henry Clifford, Radnor, Pennsylvania; Mr. and Mrs. Ralph F. Colin, New York; Mr. and Mrs. Richard S. Davis, Wayzata, Minnesota; Mr. and Mrs. Matthew H. Futter, New York; Mr. and Mrs. Harold Hecht, Beverly Hills, California; Mr. and Mrs. Alex L. Hillman, New York; Mr. and Mrs. Sam Jaffe, Beverly Hills, California; Mr. and Mrs. Gustav Kahnweiler, Gerrards Cross, Buckinghamshire, England; André Lefevre, Paris; Mr. and Mrs. Isadore Levin, Detroit; Mr. and Mrs. Arnold Harold Maremont, Winnetka, Illinois; Mr. and Mrs. Samuel A. Marx, Chicago; Mr. and Mrs. Morton G. Neumann, Chicago; Mrs. Albert H. Newman, Chicago; Clifford Odets, Beverly Hills, California; Haakon Onstad, Munkedal, Sweden; Niels Onstad, New York; Mr. and Mrs. Joseph Pulitzer, Jr., St. Louis, Missouri; Mr. and Mrs. Bernard J. Reis, New York; Mr. and Mrs. David Rockefeller, New York; Nelson A. Rockefeller, New York; Mr. and Mrs. Peter A. Rübel, Cos Cobb, Connecticut; Hermann and Margrit Rupf Foundation, Bern, Switzerland; Hermann Rupf, Bern, Switzerland; Mr. and Mrs. Daniel Saidenberg, New York; Mr. and Mrs. Leo Simon, New York; Mr. and Mrs. G. David Thompson, Pittsburgh; Mr. and Mrs. Burton G. Tremaine, Meriden, Connecticut; Dr. Herschel Carey Walker, New York; Mr. and Mrs. George Henry Warren, New York; Mr. and Mrs. Harry L. Winston, Birmingham, Michigan.

Kunstmuseum, Basel, Switzerland; Albright Art Gallery, Room of Contemporary Art, Buffalo, New York; The Art Institute of Chicago; The Minneapolis Institute of Arts; The Solomon R. Guggenheim Museum, New York; The Museum of Modern Art, New York; Smith College Museum of Art, Northampton, Massachusetts; Rijksmuseum Kröller-Müller, Otterlo, The Netherlands; Philadelphia Museum of Art; Washington University, St. Louis, Missouri; The Phillips Collection, Washington, D.C.

Peter H. Deitsch Gallery, New York; Fine Arts Associates, New York; Hanover Gallery, London; Galerie Louise Leiris, Paris; Saidenberg Gallery, New York.

Exhibition Dates

The Museum of Modern Art, New York: April 9 – June 1, 1958
The Minneapolis Institute of Arts: June 24 – July 24
San Francisco Museum of Art: August 11 – September 14
Los Angeles County Museum: September 29 – October 26

CONTENTS

ACKNOWLEDGMENTS

Anyone attempting to write about the life and work of Juan Gris must be indebted first of all to Daniel-Henry Kahnweiler, the artist's principal dealer and lifelong friend, whose records and published works on Gris are indispensable source material. The carefully prepared scrapbooks and catalogues of the late Curt Valentin, Gris' most consistent champion among New York dealers, have also proved extremely valuable, and were made available by Jane Wade, formerly associated with his gallery.

I am indebted, too, to René d'Harnoncourt, Director of the Museum of Modern Art, who personally arranged some of the most important European loans to the exhibition which this book describes. Sam Hunter, Associate Curator of the Museum's Department of Painting and Sculpture, has been tireless and skilled in working on the difficult problem of tracing and assembling many of the pictures shown on the following pages, and has made important editorial suggestions; he has been most ably assisted by Alicia Legg of the same Department. Karen Serkes has been responsible for the many details of correspondence. Frances Pernas in the Publications Department has seen the book through the press with her expected dispatch and sensitivity, and Charles Oscar has designed its pages.

For generous support of the book I would like to thank the following: Mr. and Mrs. Leigh B. Block; Mr. and Mrs. Ralph F. Colin; Mr. and Mrs. Alex L. Hillman; Mr. and Mrs. Seymour H. Knox; Mr. and Mrs. Samuel A. Marx; Mr. and Mrs. Morton G. Neumann; Haakon Onstad; Niels Onstad; Nelson A. Rockefeller; Mr. and Mrs. Peter A. Rübel; Mr. and Mrs. G. David Thompson; Dr. Herschel Carey Walker; Saidenberg Gallery, New York.

For advice as to the contents of the book and the exhibition, I am grateful to Alfred H. Barr, Jr., Ralph F. Colin, Margaret Miller and Monroe Wheeler. Finally, I should like to thank Jacques Lipchitz for his kindness and interest in talking to me at length about Gris, his close friend.

JAMES THRALL SOBY
Director of the Exhibition

(All works in the exhibition are illustrated)

JUAN GRIS

"This Juan Gris, who lived only a short time, had little good fortune and never pushed his way to the fore, was one of the very great ones. His place is next to those painters whom he loved, next to Jean Fouquet, Mathieu Le Nain, Boucher, Ingres, Cézanne." These are the concluding words in an early monograph on Gris,[1] written by Daniel-Henry (Kahnweiler), the artist's first dealer and lifelong champion, of whom Gertrude Stein rightly declared: "No one can say that Henry Kahnweiler can be left out of him [Gris]."[2]

In view of Kahnweiler's close friendship with the artist, his list of Gris' idols in the art of the past is unquestionably accurate. It is nevertheless in part a puzzling list at first glance. Gris' reverence for Fouquet's stern geometry and "abstract" color is understandable; it is confirmed by the fact that a reproduction of the great fifteenth-century master's *Etienne Chevalier and his Patron St. Stephen* appears in a 1926 photograph of Gris' studio at Boulogne.[3] That Gris, like his countryman and colleague in cubism, Pablo Picasso, should also have learned much from Ingres' linear discipline, is reasonable, and by now everyone understands Cézanne's contribution to the evolution of the cubists' esthetic. But Le Nain's place in the galaxy is less easy to explain, since genre painting, as the Le Nain brothers practiced it, would presumably have held little appeal for an artist like Gris, for whom architectonic solutions of form were important.* Perhaps in this case Gris' admiration was more a matter of psychological than stylistic affinity; his own career, like that of the Le Nains, was marked by humility of vision. And we should remember Gris' almost total adoration of the French tradition in art. Spanish-born, he preferred to think of himself as French, and with friends insisted that he be called "Jean" rather than "Juan." As to Boucher, there are paintings by Gris in which azure passages are not unrelated to the art of Madame Pompadour's estimable decorator, and at times Gris' use of repetitive, circular elisions connects him, however obliquely, to the Rococo style.

The name of Boucher by no means completes the list of French painters at whose works Gris looked with special interest. On one occasion, for example,

[1] Kahnweiler, bibl. 35, p. 13
[2] Stein, bibl. 94, p. 162
[3] Kahnweiler, bibl. 37, p. 136, plate 54

* It should be noted, however, that the compositions of Mathieu Le Nain, Gris' favorite, were more sophisticated and carefully calculated than those of his brothers, and were in fact nearer in spirit to the Spanish tradition.

he remarked to Jacques Lipchitz: "In many ways I feel at one with Seurat,"[4] and a number of his drawings parallel Seurat's in what Maurice Raynal has called their "*sublime familier.*"[5] Yet, oddly enough, Gris at times was troubled by the very purity which he and Seurat proposed in their separate ways. In 1915 he wrote: "At all events I find my pictures excessively cold. But Ingres is cold too, and yet it is good, and so is Seurat; yes, so is Seurat whose meticulousness annoys me almost as much as my own pictures."[6] At any rate, Gris did not reserve his enthusiasm for the unquestioned luminaries in French art. We have Kahnweiler's word and Gertrude Stein's that some of the artist's figure compositions of 1923–25 were inspired by the sixteenth-century Fontainebleau Mannerists, whose meaning for most of Gris' contemporaries was negligible. On his ardent tours of French museums, Gris made other relatively personal discoveries, among them Philippe de Champaigne, then chiefly admired by art historians. Yet we must not forget that Gris, however devout a Francophile, remained in essence a Spanish painter. It is significant that Picasso, to whom Gris' art owed most, should have exclaimed before the latter's portrait of his wife Josette ". . . it's much more beautiful than Zurbarán."[7]

YOUTH IN SPAIN

José Victoriano Gonzalez, later to be known as Juan Gris, was born in Madrid on March 23, 1887, of Castilian and Andalusian stock. He was thus the only one of the four major cubists to have been born in a capital city, Picasso having come from Málaga, Braque and Léger from small French towns. The fact has an ironical aspect in that Gris remained more of a provincial in some regards than his three great colleagues, notably in his ingenuousness – "Gris was absolutely, incredibly naïve,"[8] his close friend Lipchitz has told the present writer – and in the shy awkwardness of mind sometimes revealed by his published letters. Yet place of birth usually has far less to do with emotional and intellectual development than environment in youth, and we must remember that at thirteen Picasso moved with his family to Barcelona – the liveliest cultural center in Spain – while Braque and Léger were drawn into the Parisian orbit quite soon and in any case

[4] Buchholz Gallery, bibl. 64 (1944), Lipchitz preface
[5] Raynal, bibl. 89, p. 552
[6] *Gris Letters*, bibl. 8, pp. 33, 34
[7] Richardson, John, 'Juan Gris en Suisse.' *XXe Siècle*, no. 6, p. [64], Jan., 1956
[8] Lipchitz, Jacques [In conversation with the writer], September, 1957

Illustration for *Alma America – Poemas Indo-Españoles* by José Santos Chocano. 1906. (Not in exhibition)

were never as remote from it as was Gris, living in reactionary Madrid. It is true that Gris arrived in Paris when he was about the same age Braque and Léger had been. Meanwhile, he can have found nothing more than routine stimulation at Madrid's School of Arts and Sciences, where he studied engineering. Nor can he have profited very much from taking instruction in painting from one José Maria Carbonero, whose name has been lost in the academic undertow.

We know from Douglas Cooper's account, however, that Gris was interested in drawing while studying at the School of Arts and Sciences – "Even as a student he covered his notebooks with caricatures of his professors and classmates."[9] We know further that he made a local reputation for his humorous drawings for *Blanco y Negro* and *Madrid Comico* and had illustrated José Santos Chocano's *Alma America – Poemas Indo-Españoles* (left) before he left Madrid for Paris in 1906.

Gris' interest in caricature and humor might seem out of character with the sobriety and even pessimism to which nearly everyone who wrote about him and his career from first-hand observation has referred, though we know that wit often has its deepest roots in gloom. Still, the evidence as to Gris' sombre quality of mind is overwhelming, and is contradicted only by those few opposite descriptions of him which will appear in a moment. Thus Ozenfant has spoken of Gris' "dark racial instincts"[10] and Apollinaire once declared: "He wept romantically, instead of laughing as in drinking songs."[11] Gertrude Stein for her part took a more equivocal position than was usual for her: "To begin with he [Gris] has black thoughts but he is not sad."[12] To this description of the artist, Lipchitz has added the following in conversation with the writer: "Gris was the gayest of men, but he had fits of terrible and sudden violence. This was later in his life, and we didn't know how sick he was." The most cheerful account of Gris' temperament comes from Kahnweiler: "It is my duty . . . to tell of the Gris I knew, whose tremendous laugh could shake a whole row of any cinema which was showing a Charlie Chaplin or a Rigadin, who delighted in talking, joking and dancing and who loved to tell *gitano* stories (which, to a Spaniard, are the equivalent of Marseillais stories, Scottish stories or Jewish stories); in short, a delightful companion to his friends when his day's work was done."[13] Despite this account – and no one could question its truthfulness – the impression remains that even before his illness Gris was unusually melancholy much of the

[9] Cooper, bibl. 20, p. [5]
[10] Ozenfant, bibl. 43, p. 104
[11] Apollinaire, bibl. 15, p. 42
[12] Stein, bibl. 93, p. 16
[13] Kahnweiler, bibl. 37, p. 5

time, though his moods apparently fluctuated abruptly from joy to despair.

One wishes that more documentation were available as to Gris' youth in Madrid. So far as we know, he had no academic training in drawing at the School of Arts and Sciences, though his studies in engineering doubtless required some manual skill. Perhaps one day a thorough investigation of his schoolboy sketches and published illustrations will be made. Though the illustration from *Alma America* (page 11) is astonishingly prophetic of the direction Gris' art would eventually take, it seems safe to assume that these drawings will reflect few advanced technical preoccupations beyond an interest in the stylizations of *Art Nouveau*, known in Madrid through German publications but not nearly so influential there as in Barcelona. (The influence of *Art Nouveau* reappears in Gris' mature art from time to time.) In short, Gris as an adolescent was living in a cultural vacuum, and soon after his father's death decided to move to Paris.

1906: ARRIVAL IN PARIS

In 1906 Gris went to Paris. By some fortuitous circumstance he found lodgings in *le Bateau Lavoir* – a sort of blear tenement for artists – at number 13, rue Ravignan in Montmartre. It was probably the rising fame of his countryman, Picasso, which had attracted him to this address, and soon he came to know Picasso and through him Braque, Guillaume Apollinaire, Max Jacob, Maurice Raynal, Pierre Reverdy and other painters, poets and critics who were emerging as leaders of the new generation. Gris was at that point exclusively a graphic artist, and he contributed drawings and illustrations to *L'Assiette au Beurre, Le Charivari, Le Témoin* and *Le Cri de Paris*. The style of some of these drawings is related to that of the sketches in the German periodical, *Simplicissimus*, and reflects the waning impact of *Art Nouveau* or, as it was known in Germany, *Jugendstil*. On the other hand, a number of Gris' illustrations for *L'Assiette au Beurre* are more nearly related to the satirical tradition which runs from Daumier to Forain; their subjects usually deal with marital infidelity, amorous intrigues, money and such current topics as the suffragette movement. At times, one senses the influence of Toulouse-Lautrec and Aubrey Beardsley.

But Gris was now living in what soon became the center of the cubist uprising, and he could not have failed to be impressed by the research and activity of his colleagues, especially Picasso. He himself did not begin painting seriously until 1910 and then primarily in watercolor. It was not until the following year that he allowed any of his friends to see his new works in oil – those works which

The Bourse
Let's take advantage of the panic to line our own pockets. That will be so much to the good . . . if we are spared by the Comet.

Drawing for illustration in *L'Assiette au Beurre*, May 14, 1910, p. 116. Crayon with gouache, 13¼ × 11″. Collection Mr. and Mrs. Bernard J. Reis, New York

are amazingly authoritative for a man of his relative inexperience. He was six years younger than his three peers in cubism, Picasso, Braque and Léger, all of whom through one of nature's more amiable flukes were born in the vintage year of 1881.

Perhaps because of his comparative youth, Gris was not obliged to grope his way painstakingly toward a full acceptance of the cubist esthetic. The way had been paved for him by Picasso, whose famous *Demoiselles d'Avignon*, with its cubistic passages, had been painted the year after Gris' arrival in Paris; by Braque, who in 1908 abandoned fauvism for early cubism; even by Léger, who by 1910 had long outgrown his earlier preoccupation with realism tempered by Neo-Impressionism. The example of Picasso and Braque was there for Gris to follow. He did so with conviction and relish once his mind was made up. Thereafter it was the problem of Gris, a stubborn, dedicated man, to hold his own against a meteoric virtuoso (Picasso) and a supreme French craftsman (Braque).

Gris brought to this task a refinement of calculation and a highly original color sense which have finally won him his separate place in cubism's front rank. During most of his career he seems not to have been affected seriously by Léger's example (and Léger, as we know, lived and worked apart from the inner cubist circle), but he alternated for a time as to his preference for Picasso over Braque, or vice-versa. Thus in the autumn of 1914 he wrote Kahnweiler from Collioure a letter which contains a rather bitter reference to Picasso and concluded with the words, "I have no news of Braque, the one person who interests me most."[14] We must remember, however, that at this time Braque was in the French Army, whereas Picasso was known to be safe, and other letters attest to Gris' pride in his friendship with Picasso. Indeed, there can be little doubt that he considered his countryman his principal mentor – the man from whom he could always learn but could never teach. On the other hand, certain Braque figure pieces of 1917 may owe something to Gris, as Henry Hope has suggested.[15]

1911 AND 1912: GRIS' FIRST CUBIST PAINTINGS

"As a Spaniard he [Gris] knew cubism and had stepped through into it," Gertrude Stein wrote in "The Life and Death of Juan Gris." It would be a mistake, nevertheless, to assume that he stepped into cubism all at once and without a single backward glance. It is true that in 1911 he gradually evolved a

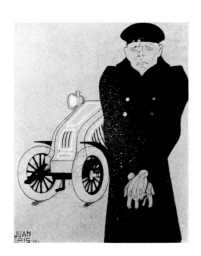

The Automobilist. 1910. Ink, pencil and gouache, 15¼ × 12¼″. Peter H. Deitsch Gallery, New York

[14] *Gris Letters*, bibl. 8, p. 15
[15] Hope, Henry R., *Georges Braque.* New York, Museum of Modern Art, 1949, p. 74

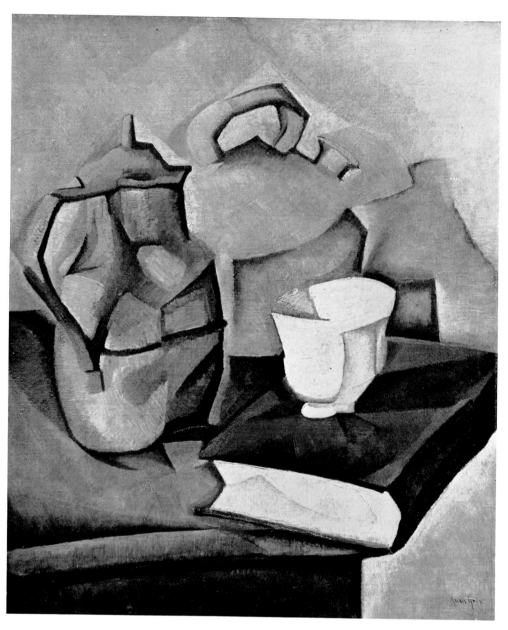

Still Life with Book. 1911. Oil on canvas, $21\frac{5}{8} \times 18\frac{1}{8}''$. Private collection, Paris

14

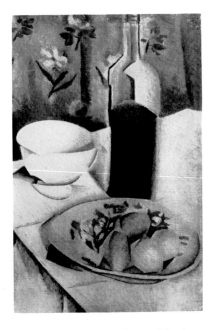

left: *Still Life with Bottle*. 1910. Crayon, 15¾ × 11¼″. Collection Mr. and Mrs. Matthew H. Futter, New York. right: *The Eggs*. 1911. Oil on canvas, 22½ × 15″. Collection Clive Bell, Firle, Sussex, England. (Not in exhibition)

personal cubist style in which immaculate prisms float in a leeward tide (pages 16 and 17). But earlier that year he had worked his way cautiously through the post impressionism of *The Eggs* (above), sometimes mistakenly dated 1912, and on to a qualified, cubist definition of form in the *Still Life with Book* (opposite). In the latter of these two pictures the deformations are still restrained, and the objects easily identified. Moreover, the color of both is varied and sensuous.

Soon, however, Gris was producing works like the *Still Life* (page 16) and *A Table at a Café* (page 17), in which conventional modeling is abandoned and the tonality becomes almost monochromatic, as in many Picassos and Braques of 1911. But whereas Picasso and Braque at that time preferred earthy tans and muted grays, Gris' palette, though no less austere, was more metallic, with a sheen (in the best sense of the word) not often found in the analytical-cubist works of his colleagues. Gris' paintings of 1911–12 are colder than theirs, a fact which seems to have troubled even so perceptive a critic as Guillaume Apollinaire.

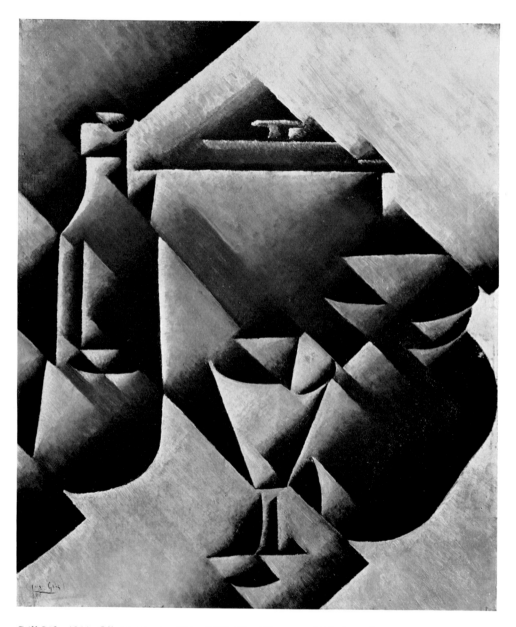

Still Life. 1911. Oil on canvas, 23½ × 19¾". The Museum of Modern Art, New York, acquired through the Lillie P. Bliss Bequest

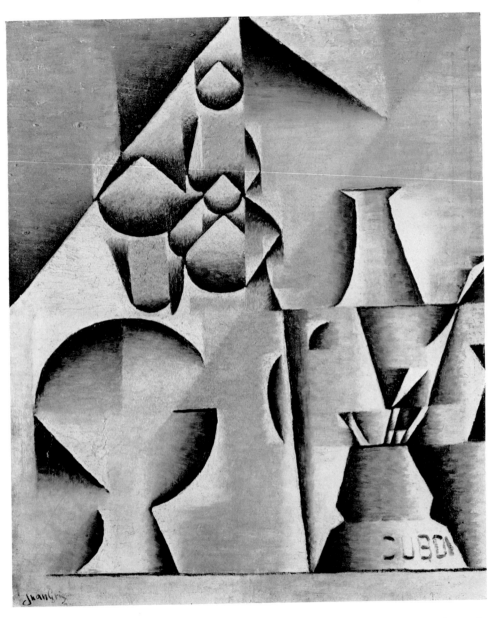

A Table at a Café. 1912. Oil on canvas, $18\frac{1}{8} \times 15''$. The Art Institute of Chicago, gift of Kate L. Brewster

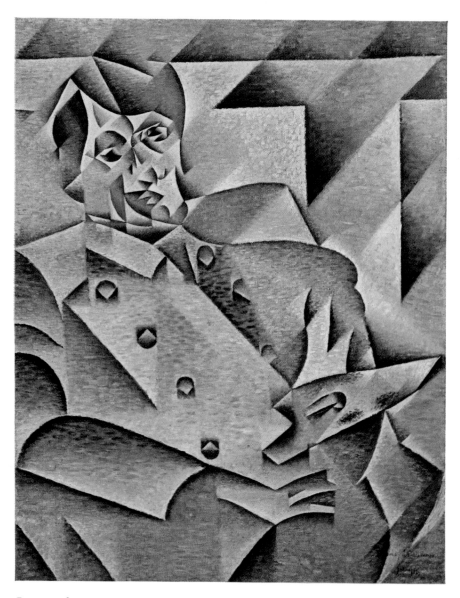

Portrait of Picasso. 1912. Oil on canvas, $37 \times 29\frac{1}{2}''$. Collection Mr. and Mrs. Leigh B. Block, Chicago

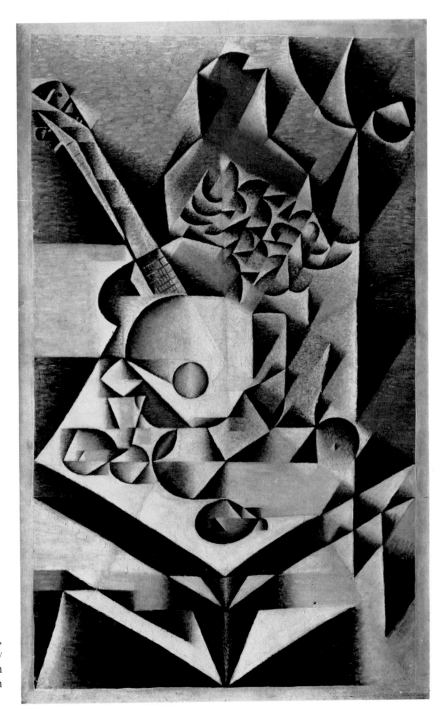

Guitar and Flowers. 1912. Oil on canvas, 44⅛ × 27⅝″. The Museum of Modern Art, New York, bequest of Anna Erickson Levene in memory of her husband, Dr. Phoebus Aaron Theodor Levene

Moreover the motion of their forms is more pronounced, as when in the *Still Life* the facets appear diagonally magnetized. Though there is no reliable evidence of a cross-influence one way or the other, Gris' art of these early years occasionally puts one in mind of Balla's Futurist compositions of 1912, though less complex and totally different in color.

Two of the greatest Gris paintings of 1912 are the *Portrait of Picasso* (page 18) and the *Guitar and Flowers* (page 19). The former is surely one of the finest portraits of the cubist movement as a whole; its steel-blue precision heightens rather than obviates the sensitivity of characterization, and the face is masterfully defined. And in the *Guitar and Flowers* we see the beginning of that quite sudden tonal enrichment which was to lead Gris, Picasso and Braque away from analytical toward synthetic cubism. The picture's sharp prisms are partly conceived in those olive grays and pale greens of which the painter was fond. But now blues and russet browns are added, and there is a new luxury of surface, achieved through stippling in certain areas.

In 1912 Gris began to include lettering in his compositions, as Braque had done before him, and the label on the bottle in *The Watch* (*The Sherry Bottle*) (page 23) introduces a note of realism for which the cubists felt a particular need at this moment. The hanging tassels at the left fortify the impression of a new reality within the cubist framework, and perhaps Gris' use of them stems from Braque's example in adding a tassel or cord to the otherwise quite abstract *Man with a Guitar* of 1911 (page 22). The delicious contrast of angular with circular forms makes *The Watch* easily one of the most beguiling of Gris' early paintings, its complexity of composition handled with remarkable assurance for a man who had joined the cubists' ranks only a year before. Moreover, mention must be made of the fact that this picture makes restrained use of pasted-on sections of printed material – an early indication of Gris' interest in *collage*, an interest which was to reach a brilliant climax in 1914.

In 1912, too, Gris painted *The Man in the Café* (opposite) for which a most complete preparatory drawing of the head exists (right). Remembering hearsay accounts of Gris' solemnity of mind, one wonders how deliberate was the picture's almost comic spirit. The complacent man with absurdly high heels seems a caricature of the member of the bourgeoisie, arrived to take his ease at a sidewalk café, staring straight ahead at the passers-by. Even the distortions of the man's face are witty, whether intentionally so or not, and at this point, perhaps assured of his growing mastery as an artist, Gris may well have worked in a more relaxed, even playful spirit.

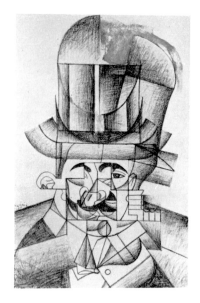

Man with an Opera Hat. Aug. 1912. Pencil, 18 × 12″. Collection Mr. and Mrs. Richard S. Davis, Wayzata, Minn.

20

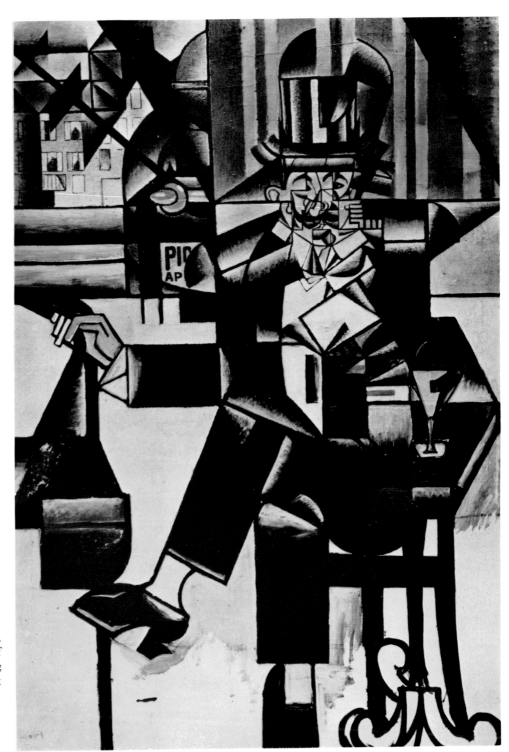

The Man in the Café. 1912. Oil on canvas, $50\frac{1}{2} \times 34\frac{5}{8}''$. Philadelphia Museum of Art, Louise and Walter Arensberg Collection. (Exhibited in New York only)

In 1913 Gris, like Picasso and Braque, began to enrich the color and forms of his paintings, in a word, progressed from analytical to what is commonly called synthetic cubism. The change is apparent in a small picture of 1913, the *Guitar and Pipe* (page 24). There is here a new variety of handling, a new emphasis on tonal and textural change, a new absorption in modeling, as when the picture frame in the background recalls the mid-nineteenth-century realism of Courbet and others. By this time Gris had begun to use contrasting techniques within a given image, and Kahnweiler's words on his innovations are apropos: "One method which was imitated later by other painters was peculiar to Gris: the objects, whose form, colour and even substance he tried to express, were frequently completed by a sort of projection in the form of a black silhouette. But he did not make a system of this. Sometimes the 'projection' alone was left to represent the object: for example, a pipe placed on the imitation wood of a table. At other times a tumbler was painted only once, carefully painted and modeled with shadows, as if seen in a sort of super-isometric projection (to coin a phrase), that is to say from a balcony or gallery."[16] Kahnweiler goes on to say that at this period began Gris' "disassociation of line and colour." The device is plainly seen in those pictures wherein contours run free of the colors they once would have contained.

The year 1913 is sometimes given as the date when Gris, following the lead of Braque and Picasso, began to use *collage* consistently. But even in 1913 he used the technique rarely and, according to Kahnweiler, not before April, though the previous year, as already noted, *The Watch* contained pasted-on fragments of printed paper. One of the finest of his 1913 *collages* is the *Violin and Engraving* (page 25), executed in April, and it is astonishing to read in Gris' published letters[17] that the artist later in the year wrote Kahnweiler to say that he felt the engraving in the background could be replaced without damage to the over-all character of the image. Kahnweiler naturally demurred. Gris, though at first seeming to agree that no such violence should be done to his picture, went on to say: "But once Mr. Brenner is the owner of the picture, he is at liberty to substitute something else for this engraving – even his own portrait if he likes. It may look better, or it may look worse, as when one chooses a frame for a picture; but it won't upset the actual merits of the picture."[18] Happily, no

[16] Kahnweiler, bibl. 37, p. 84
[17] *Gris Letters*, bibl. 8, p. 2 [18] Ibid.

Braque: *Man with a Guitar.* 1911. Oil on canvas, 45¾ × 31⅞". The Museum of Modern Art, New York, acquired through the Lillie P. Bliss Bequest. (Not in exhibition)

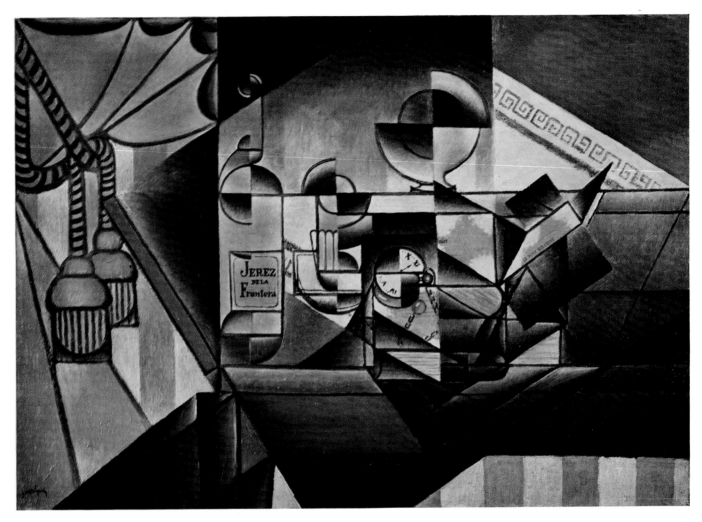

The Watch (*The Sherry Bottle*). 1912. Oil and collage on canvas, 25¾ × 36¼″. Collection Mr. and Mrs. G. David Thompson, Pittsburgh. (Exhibited in New York only)

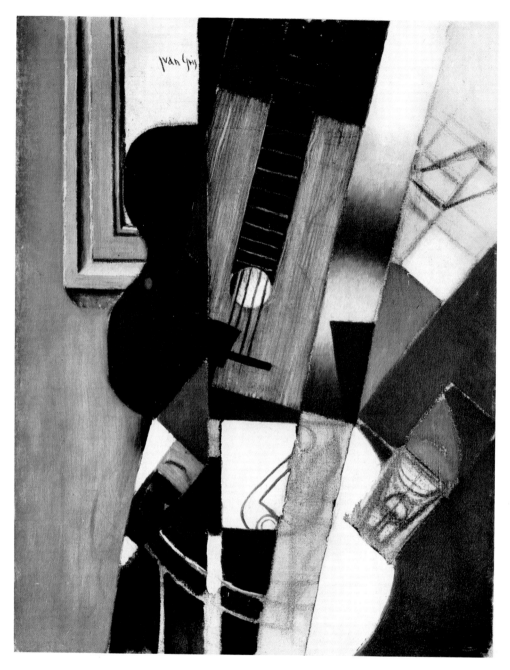

Guitar and Pipe. 1913. Oil on canvas, $25\frac{1}{2} \times 19\frac{3}{4}$. The Museum of Modern Art, New York, gift of the Advisory Committee

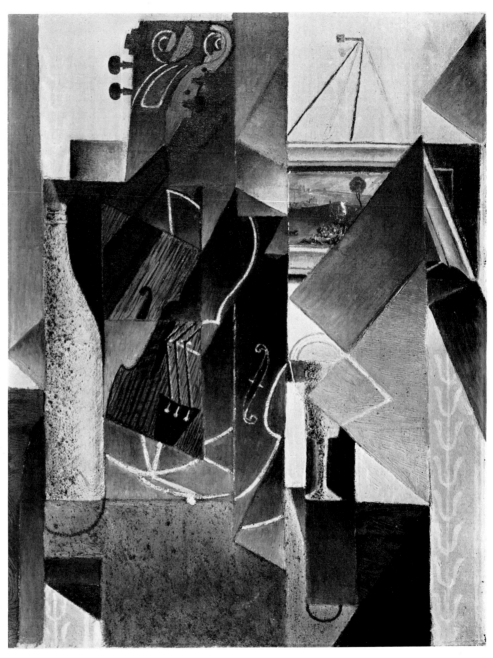

Violin and Engraving. April 1913. Oil and collage on canvas, $25\frac{5}{8} \times 19\frac{5}{8}''$. The Museum of Modern Art, New York, bequest of Anna Erickson Levene in memory of her husband, Dr. Phoebus Aaron Theodor Levene

substitution for the engraving has ever been made. Nevertheless, Gris' views on the unimportance of the matter are of interest, though one doubts that he would have held them with regard to his magnificently adroit *collages* of the following year. Perhaps he felt that the pasted-on image in the *Violin and Engraving* was a minor detail, and certainly it is dominated by painted sections of exceptional force and perceptivity, among them the skillfully modeled bottle and glass.

In August, 1913, Gris and his wife joined Picasso at Céret near the Spanish border. They remained until November. This was the first time Gris had left Paris since his arrival in 1906. He was delighted by the change and perhaps also, despite his persistent disclaimers of any interest in his native land, by his proximity to Spain. At any rate, during his months at Céret he worked superbly, producing such works as the *Violin and Guitar* (page 29), which he describes in a letter to Kahnweiler as his own favorite up to that point, and the wry *Smoker* (page 30). In October he completed the two pictures entitled *Still Life with Pears* (page 32) and *Violin and Checkerboard* (page 33). The first of these two paintings shows a compositional similarity to a Gris painting of 1914 called *The Chair* (page 34), a work comparable in subject to what is said to have been Picasso's first *collage* – the *Still Life with Chair Caning* of 1911–12 (page 34).

Though Gris' contribution to analytical cubism had been his own and admirable, there can be no doubt that he welcomed the technical and stylistic expansion which synthetic cubism allowed him. The *Violin and Guitar* of 1913 is daring in color. But its pyramidal maze of forms based on musical instruments is compelling. Indeed, the taut, elegant and inevitable contours of the violin had more persistent meaning for Gris than for his fellow-cubists. It is true that Braque also had been fascinated by violins and had accentuated their keys, scrolls and sound holes in a number of works, among them the *Still Life with Violin and Pitcher* of 1909–10 (page 28). Picasso, on the other hand, made more frequent use of the guitar and mandolin, whose rounded outlines better suited his purpose. There has been a considerable amount of theorizing as to why musical instruments meant so much to the cubists in general, and the musical inclinations of Picasso, Braque, Gris and the others have perhaps been over-stressed. It seems to the writer more plausible to assume that the cubists, in their arduous task of reappraising everyday appearances through a new and revolutionary plastic system, liked the violin, the guitar and the mandolin because the basic design of these instruments had undergone very little change for several centuries. Their challenge to the cubists was therefore all the more explicit. At any rate, the violin's complexity of design appears in a sense to symbolize the conscientious

intellectuality which Gris brought to cubist research. This is not to say, of course, that he was more intellectual than his two great colleagues. But he was, one assumes, more metaphysical in his conception of how the commonplace and the traditional could become the point of departure for a new order in painting.

Gris worked in a more lighthearted mood in the *Smoker* (page 30), whose fanlike disposition of flat planes and tubular contrasts of form are memorable and effective, and can more easily be read in the drawing of the same subject (page 30). Like *The Man in the Café* (page 21) of the previous year, the *Smoker* is gay in temper and helps qualify the impression of Gris' unyielding solemnity of which some of his friends have spoken. Considering the affection with which Gris was regarded by those closest to him, considering even such characteristics as his love of dancing, often mentioned in his letters, he cannot have been a cold personality. Nor is the best of his art by any means congealed, though unlikely people have thought so, including the late Piet Mondrian, who, when told by the American painter Carl Holty that critics and admirers were at last grouping him in importance with Picasso and Juan Gris, protested firmly: "Oh, not Juan Gris! He is much too cold and intellectual."[19]

Two of Gris' masterworks of 1913 are the *Still Life with Pears* and the *Violin and Checkerboard* (pages 32 and 33). In these paintings we can easily recognize what was to become an earmark of Gris' art – the echoed application of comparable shapes to objects of differing character and identity within a given composition. In Douglas Cooper's words, "One finds, for example, the same

[19] Holty, Carl, "Mondrian in New York: a Memoir." *Arts* 31, no. 10, Sept., 1957, p. 18. Most recently, Georges Braque has also commented on the calculation of Gris' art, but not without generously acknowledging its redeeming qualities. The following statements were made by the French artist to John Richardson, and appeared in an interview printed by *The Observer* (London) December 1, 1957: ". . . For, alas, Cubism was very quickly destroyed; too many mediocre painters pounced on it. But I make an exception of Juan Gris, for he managed to transcend his theoretical approach. Of course even he was often led astray by science. I remember on one occasion Gris showing me a still-life. It didn't seem entirely successful so I made a few criticisms, whereupon Gris looked at it again and, after pondering a bit, exclaimed, 'My God! you're right: I've made a mistake in my calculations.' A terrifying admission, wasn't it? 'You had better be careful,' I said to him, 'or else one day you are going to find yourself trying to fit two fruit-dishes into a single pear!'

"At its best, however, Gris' painting is permeated with a feeling of struggle and that's what really redeems it. If the phrase 'abstract painting' can be applied to anybody's work – and I must confess it has always struck me as a contradiction in terms – I would say that it applies to that of Gris. . . ."

oval form used in a single canvas to express the beak of a flute, the sphere of a glass, the neck of a bottle, the rose of a guitar and a bunch of grapes on a fruit bowl."[20] Thus in the *Still Life with Pears* the round profile of a glass is played against the top of a second glass seen from a contrasting angle (that is, from above); both forms are repeated in the foreground's cluster of grapes.

An even more extreme example of this ancient and eloquent device is to be found in the *Violin and Checkerboard*, wherein the designs on the wallpapered background repeat the serpentine outlines of the bouts and sound holes of the violin. We have already come across this device as early as 1906, long before Gris was exposed to the cubists' esthetic, in one of the artist's illustrations for *Alma America* (page 11), an image in which the contours of a guitar are extended into the accompanying backdrop. But Gris was far too subtle an artist to over-emphasize equivalents of form. His inventive variety is unmistakable in the *Violin and Checkerboard*, as when the cylindrical dice cups are juxtaposed with the unyielding squares of the checkerboard. Almost every critic who has written about Gris has mentioned his meticulous control of relationships between commonplace objects, as when Maurice Raynal declared: "Juan Gris guides his many-sided sensibility toward surrounding things, just as others direct theirs toward the heavens or their mirror; he thus invites us to take part in an intimate communion with the very essence of the objects he proposes to paint."[21] It remains to be said that Gris himself has given the best definition of his esthetic aims: "Therefore I will conclude by saying that the essence of painting is the expression of certain relationships between the painter and the outside world, and that a picture is the intimate association of these relationships with the limited surface which contains them."[22]

The tonal enrichment to which Gris had progressed since 1912 may be understood if we compare the *Portrait of Picasso* (page 18), in which a nearly monochromatic severity is relieved only by the dabs of bright color on the palette its subject holds, with the *Still Life with Pears*, of 1913, discussed above. In the latter picture, rose and blue cloths or draperies contrast with the marbleized brown of the table on which the dark pears and grapes are placed; they contrast even more violently with the almost oriental yellow of the newspaper – obviously *Le Matin*, from the Victorian lettering of the word "Le" – the straw caning of the chair and the buff-orange of its wooden back.

[20] Cooper, bibl. 20, p. [11]
[21] Raynal, bibl. 89, p. 538
[22] Kahnweiler, bibl. 37, p. 144

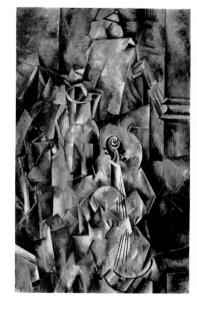

Braque: *Still Life with Violin and Pitcher*. 1909–10. Oil on canvas, 46½ × 28¾″. Kunstmuseum, Basel. (Not in exhibition)

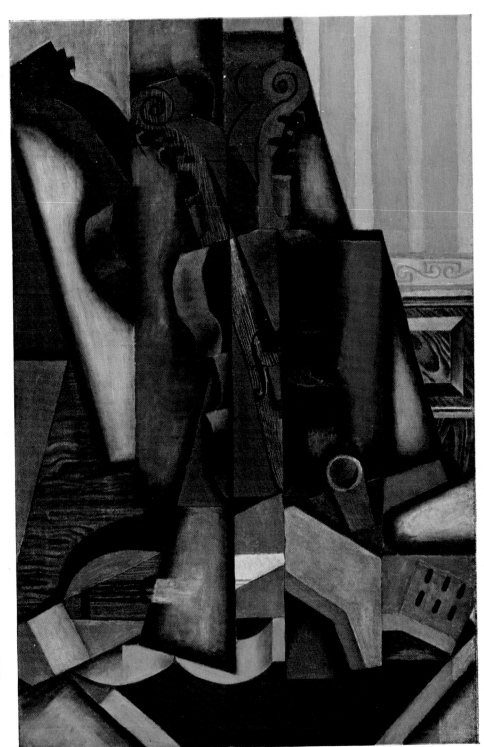

Violin and Guitar. 1913. Oil on canvas,
$39\frac{1}{2} \times 25\frac{3}{4}''$. Collection Mr. and Mrs.
Ralph F. Colin, New York. (Exhibited
in New York only)

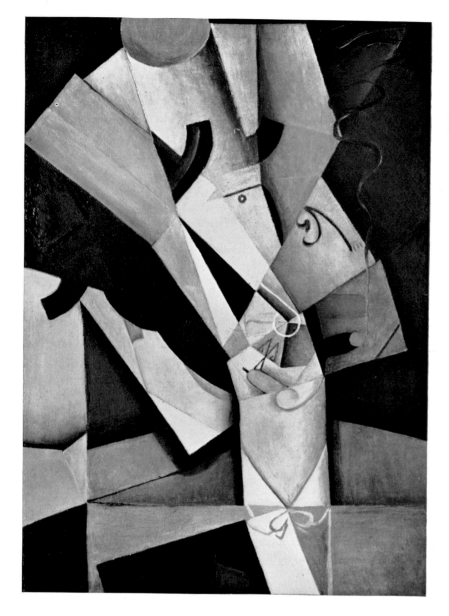

Smoker. 1913. Oil on canvas, $28\frac{7}{8} \times 21\frac{1}{2}''$. Collection Mr. and Mrs. Armand P. Bartos, New York

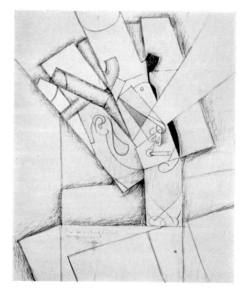

Smoker. 1912. Crayon, $28\frac{1}{2} \times 23\frac{3}{4}''$. Collection Mr. and Mrs. G. David Thompson, Pittsburgh. (Exhibited in New York only)

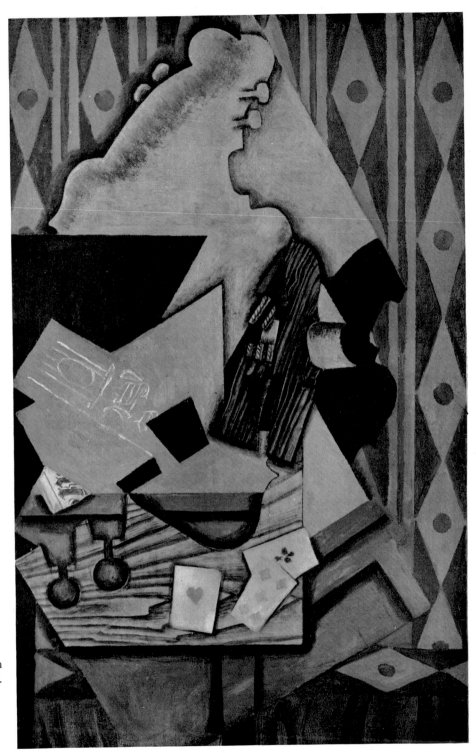

Still Life with Playing Cards. 1913. Oil on canvas, 39¼ × 25½". Collection Mr. and Mrs. Samuel A. Marx, Chicago

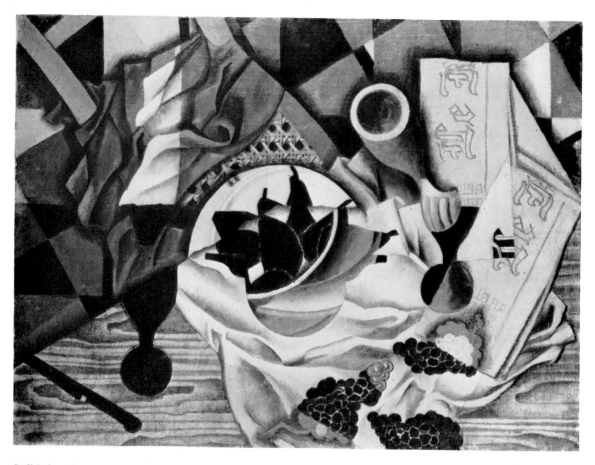

Still Life with Pears. Oct. 1913. Oil on canvas, 21¼ × 28¾″. Collection Mr. and Mrs. Burton G. Tremaine, Meriden, Conn.

By this time Gris has become the original colorist he was to remain throughout the remainder of his short career. Indeed, his color is one of his most inimitable gifts, unpredictable to extreme degree, variable and running the gamut from luxury to terse sobriety. Possibly one reason why Gris' fame for a long time lagged behind that of his greatest colleagues in cubism, is the fact that his paintings' qualities are often lost in the black-and-white reproductions which served to spread the fame of Picasso and Braque. This is not to claim that he was a finer colorist than they; it is to assert that his color is unusually elusive and hard to hold accurately in memory, so that only through a careful study of his paintings themselves can one arrive at anything like a fair estimate of his worth.

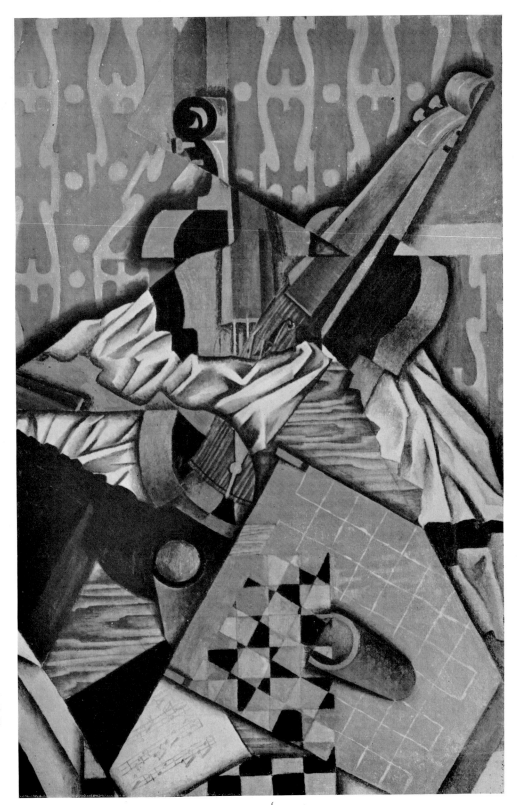

Violin and Checkerboard. Oct. 1913.
Oil on canvas, $39\frac{1}{2} \times 25\frac{3}{4}''$. Collection
Mr. and Mrs. Leo Simon, New York

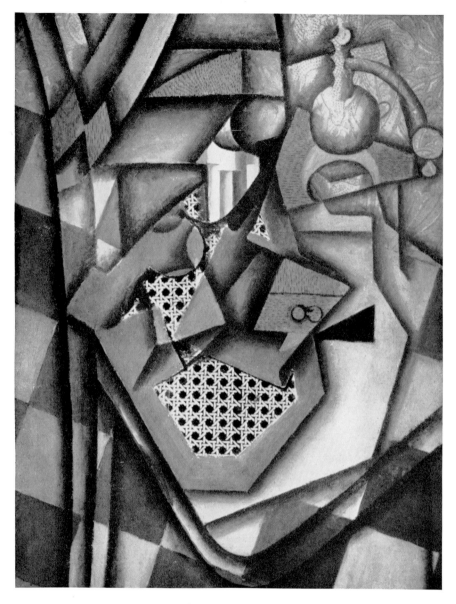

The Chair. 1914. Collage, 24 × 18″. Private collection, Paris. (Not in exhibition)

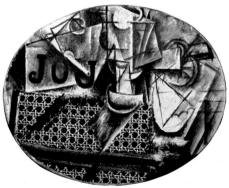

Picasso: *Still Life with Chair Caning.* 1911–12. Oil and pasted oilcloth simulating chair caning on canvas, $10\frac{5}{8} \times 13\frac{3}{4}''$. Owned by the artist. (Not in exhibition)

The same might be said of most modern painters, of course. Nevertheless, Gris' case is a special one, like that of Chardin whom he revered. A requisite for full appreciation of his talent is a prolonged familiarity with his works.

1914: THE GREAT YEAR OF GRIS' *PAPIER COLLÉS*

By November, 1913, when Gris returned from Céret to Paris, he had begun to win a limited but important recognition, thanks to the efforts of Kahnweiler, who the year before had signed a contract to buy all his works. He had already sold a picture (in 1912) to Hermann Rupf of Bern, whose Gris collection remains one of the finest in existence, and now his paintings were being acquired by Gertrude Stein and Léonce Rosenberg, later to become his dealer temporarily when the First World War forced Kahnweiler, a German citizen, to leave Paris. If his admirers were few compared to Braque's and, above all, Picasso's, his champions were effective. To Gertrude Stein in particular much credit must go for his ascending fame. She wrote about him and his art more warmly than about any other artist with the exception of Picasso; she cajoled or bullied many visitors to her celebrated apartment on the rue de Fleurus into taking him seriously as a cubist of the first rank.

Gris spent the first months of 1914 in Paris, but in June he and his wife went to Collioure, a small fishing village not far from Céret in the *Pyrenées Orientales*. Matisse had owned a villa there since 1905, and returned in September, 1914, this time with Marquet, and saw a great deal of Gris. The two painters' friendship is commemorated by the fine *Still Life with Fruit Bowl* (page 66) which Gris gave Matisse soon after it was painted in 1916. Josette Gris at this time posed often for Matisse, who knew that his younger colleague was badly in need of the small sums then paid to professional models.

Since Matisse by 1914 was a renowned figure and had always been a strong and persuasive personality, it might be assumed that he would have exerted some influence on the younger Spanish painter who was now his friend. On the contrary, both Kahnweiler[23] and Alfred Barr[24] have suggested that Matisse may at this point have been influenced to some degree by the cubism of Gris. At any rate, from 1914 date some of the finest pictures of the latter's career – those breathtakingly inspired *collages* which are assuredly among the most perfect works of art of our time.

[23] Kahnweiler, bibl. 37, p. 11
[24] Barr, Alfred H. Jr., *Matisse: His Art and His Public*. New York, Museum of Modern Art, 1951, p. 168

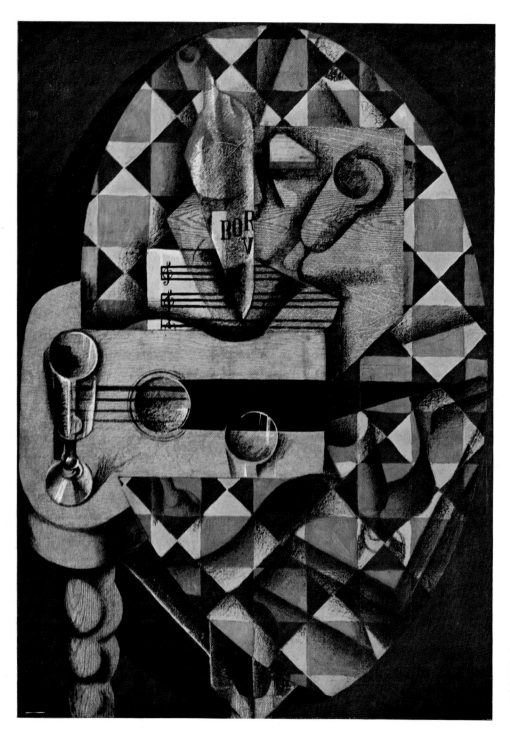

Guitar, Glasses and Bottle. 1914. Collage, gouache and crayon on canvas, $36\frac{1}{4} \times 25\frac{1}{2}''$. Collection Nelson A. Rockefeller, New York

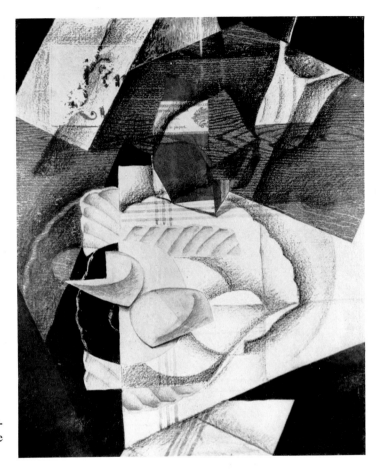

Still Life with Fruit Bowl. 1914. Collage, watercolor, charcoal and pencil, $17\frac{1}{2} \times 14\frac{1}{2}''$. Private collection, New York

These *collages* differ from the *collages* of Picasso and more especially Braque in their use of vibrant, bold color. As numerous critics have pointed out, Gris' *collages* are paintings, whereas those of Braque are primarily drawings, with tonal elements held in careful restraint. But since Braque is sometimes credited with having been the first of the cubists to introduce *collage* in his work, his words on the subject are worth re-recording and probably define Gris' attitude as well: "The pasted papers, the imitation woods – and other elements of a similar kind – which I used in some of my drawings, also succeed through the simplicity of the facts; this has caused them to be confused with *trompe l'oeil*, of which they are the exact opposite. They are also simple facts, but are *created*

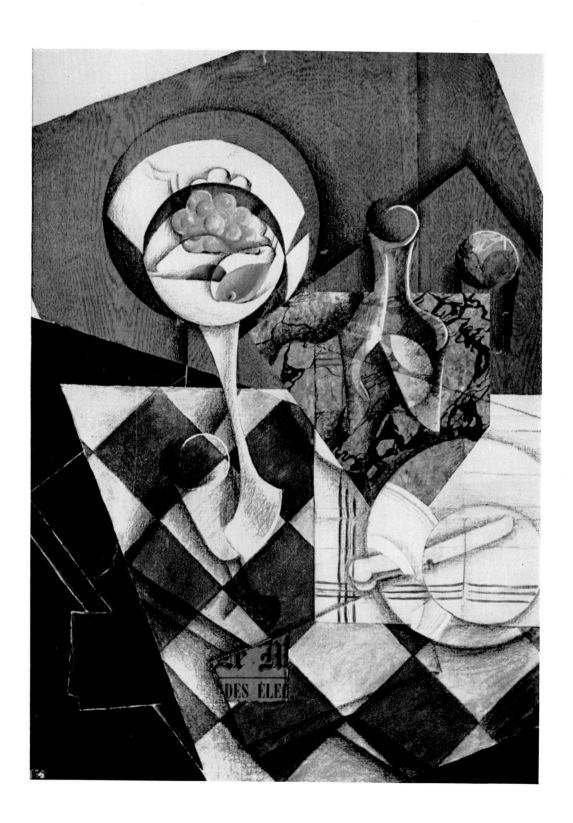

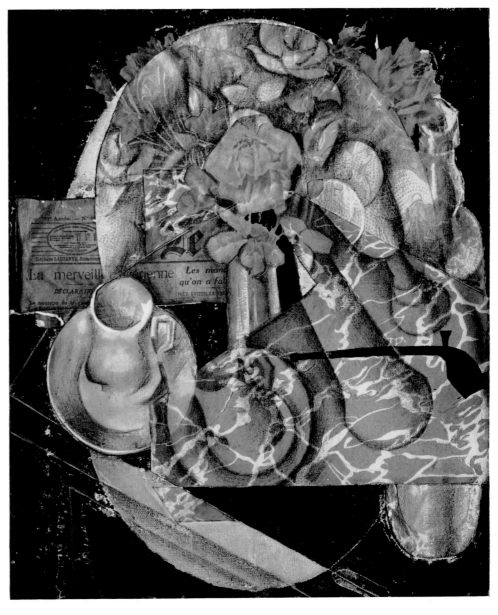

Roses. 1914. Collage, 18⅛ × 21⅝″. Private collection, Paris. (Not in exhibition)

opposite: *Fruit Bowl and Carafe*. 1914. Collage, 36½ × 25½″.
Rijksmuseum Kröller-Müller, Otterlo. (Not in exhibition)

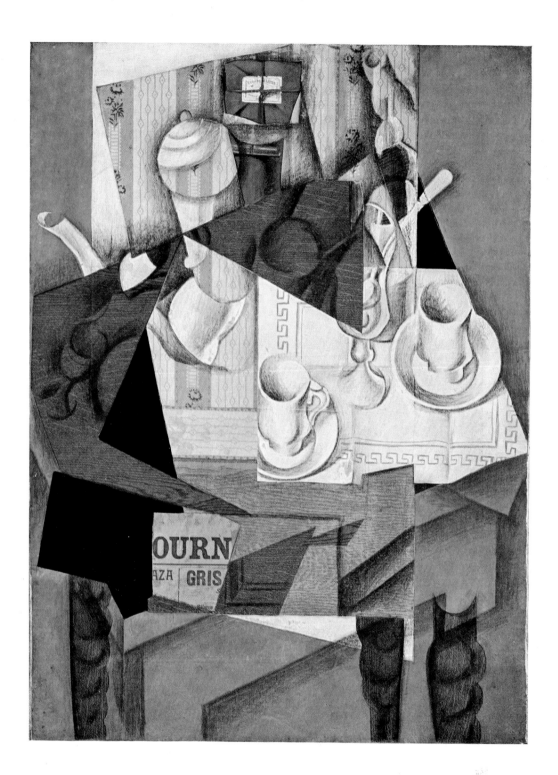

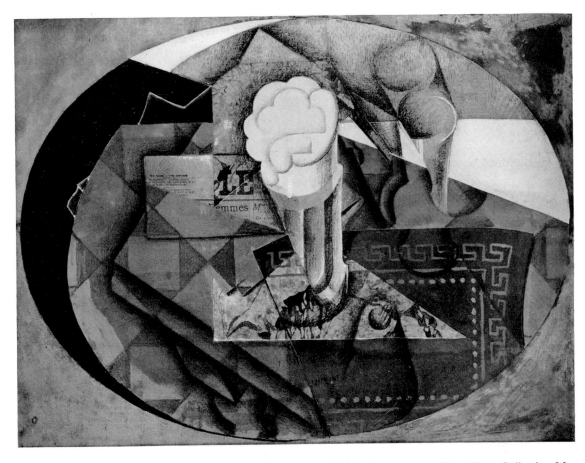

Still Life with Glass of Beer. 1914. Collage, oil, charcoal, pencil and ink on canvas, $20\frac{1}{4} \times 28\frac{1}{2}''$. Collection Mr. and Mrs. Samuel A. Marx, Chicago

opposite: *Breakfast.* 1914. Collage, crayon and oil on canvas, $31\frac{7}{8} \times 23\frac{1}{2}''$.
The Museum of Modern Art, New York, acquired through the Lillie P. Bliss Bequest

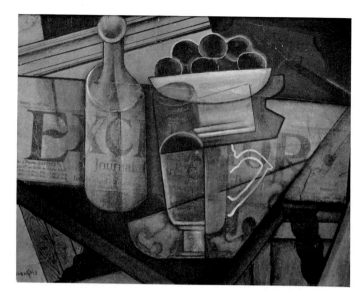

Still Life with Grapes. 1914. Collage, oil, water-color, crayon and pencil on cardboard, 10 × 13″. Collection Mr. and Mrs. Harold Hecht, Beverly Hills, Calif.

by the mind, and are one of the justifications for a new form in space."[25]

Though Gris' *collages* of 1914 seem at first glance to resemble each other closely, the truth is that their variety is almost as remarkable as their certainty of execution. The *Guitar, Glasses and Bottle* (page 36), with its contrasts of black, brown, greens and grays is relatively subdued in color, its mood austere and its impact sharpened by one of those subtle transpositions of form through which, in this case, the grained table assumes the shape of a guitar. And then in such major works as the Kröller-Müller Museum's *Fruit Bowl and Carafe* and the *Roses* from a famous private collection in Paris (pages 38 and 39), the color becomes more luxurious, the details more realistic, while translucent marbleized areas are used to extraordinary effect. Neither of these capital works, alas, could be included in the exhibition, due to their fragility. But the Museum of Modern Art's *Breakfast* (page 40) is easily their peer, and we need only compare it with the *Guitar, Glasses and Bottle* to understand the painter's inventive range in his *collages* of 1914. Gris worked with such assurance in this period and medium

[25] Braque, Georges, *Reflections on Painting.* In Goldwater, Robert & Treves, Marco, Artists on Art. New York, Pantheon Books, 1945, pp. 422, 423. (Translation of: Pensées et réflexions sur la peinture. *Nord-Sud,* no. 10, Dec., 1917, p. 5)

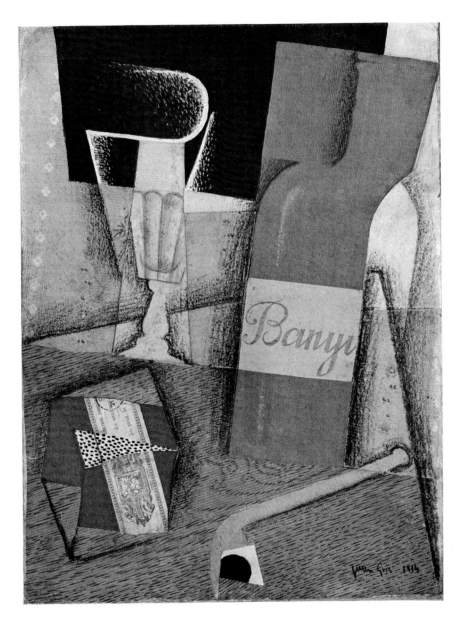

The Bottle of Banyuls. 1914. Collage, oil and crayon on cardboard, $15 \times 11\frac{1}{4}''$. Collection Mr. and Mrs. Peter A. Rübel, Cos Cob, Conn.

that whether his vision was expressed through the dulcet, gay forms and colors of the *Breakfast* or the dramatic contrasts of the *Guitar, Glasses and Bottle*, he remained an inspired master.

His awe-inspiring sensitivity and control are confirmed, too, by such works as the *Still Life with Glass of Beer* (page 41) and even by smaller pictures like *The Bottle of Banyuls* (page 43), the *Still Life with Fruit Bowl* (page 37) and the works owned by the Philadelphia Museum and the Smith College Museum of Art (opposite, and page 46). During the year 1914 Gris seemingly could do no wrong in his handling of *collage*. To his images of that time the word "exquisite" can be applied with strength and meaning; their eloquence is haunting, their reappraisal of everyday appearances is art of an exceptionally perfect order.

It should be remembered, too, that Gris' use of "applied" reality was as courageous as that of his fellow-cubists. To *The Marble Console* (page 47), for example, he affixed a piece of mirror. He had done so earlier in *The Dressing Table* of 1912, and long afterwards explained to Michel Leiris: "You want to know why I had to stick on a piece of mirror? . . . Well, surfaces can be re-created and volumes interpreted in a picture, but what is one to do about a mirror whose surface is always changing and which should reflect even the spectator? There is nothing else to do but stick on a real piece."[26] One can imagine how Jan van Eyck in painting the Arnolfini portrait would have demurred, and Velásquez in completing the Rokeby *Venus Before a Mirror*, but one can only admire Gris' boldness in adding so unyielding and positive a substance to his pictures.

THE RETURN TO PARIS; THE PAINTINGS OF 1915

With the outbreak of war Gris' emotional and financial difficulties became acute. A Spanish citizen, he was naturally exempt from French military service. But he was also unable to return to Spain, since there in youth he had neither served in the Army nor paid the required exemption tax. Kahnweiler was in Rome, without adequate funds to be of much help. Various friends, including Matisse and Gertrude Stein, tried to relieve Gris' despair with small sums of money and various plans for his support, but the artist and his wife, Josette, had to struggle hard to survive in an atmosphere of suspicion (of foreigners like himself), desperate news from the Front, where so many of Gris' French friends and colleagues were stationed, and bleak poverty. On October 31, 1914, discovering

[26] Kahnweiler, bibl. 37, pp. 87–88

44

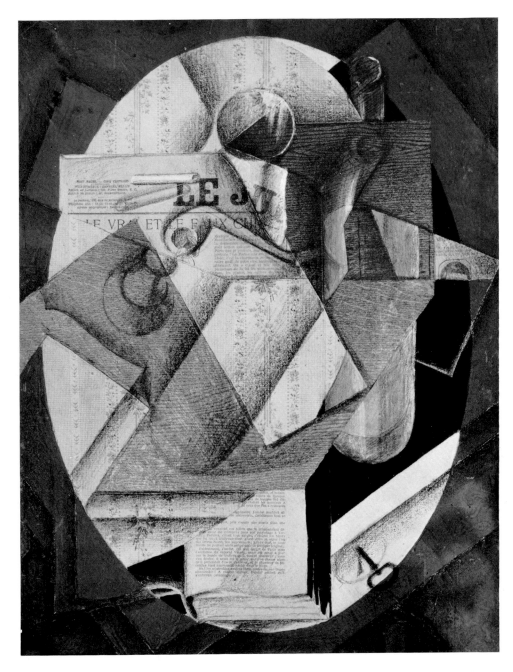

The Table. 1914. Collage and gouache on canvas, $23\frac{1}{2} \times 17\frac{1}{2}''$. Philadelphia Museum of Art, A. E. Gallatin Collection

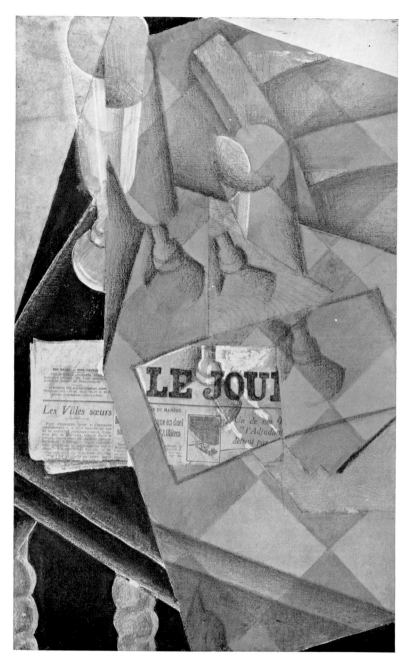

Still Life. 1914. Collage, gouache, oil and crayon on canvas, $24 \times 15''$. Smith College Museum of Art, Northampton, Mass.

46

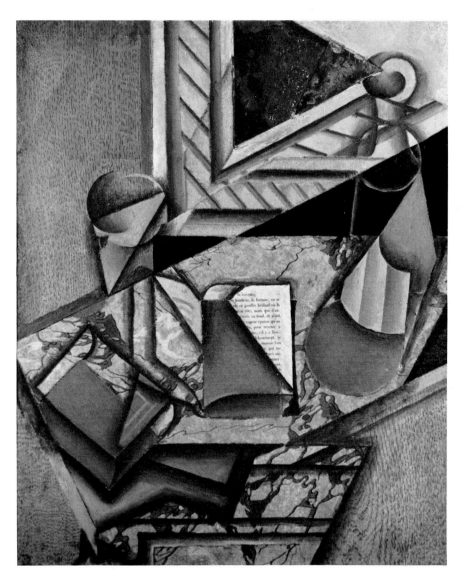

The Marble Console. 1914. Collage, and oil with mirror glass on cloth, $23\frac{7}{8} \times 19\frac{5}{8}''$. Collection Mr. and Mrs. Arnold H. Maremont, Winnetka, Ill. (Exhibited in New York only)

that their return ticket to Paris expired the following day, the Gris's returned to their old apartment in Montmartre. Their arduous journey by train is recounted graphically in one of Gris' letters to Kahnweiler.[27] At first the painter was relieved to be back in Paris, but by April of the next year he was writing Kahnweiler: "Believe me, life at this time is not much fun, and although I used to be very fond of Paris I would gladly leave it now. I do nothing but fret and am bored all the time."[28]

Nevertheless, he kept on painting. In the spring Léonce Rosenberg began to buy paintings directly from Gris, in the absence of Kahnweiler, who had moved to Bern and who consented gladly to any arrangement which would assure an outlet for Gris' pictures.*

If Gris' mood was almost unrelentingly black in 1915, as his letters attest, his paintings through some blissful irony became more opulent than before, and the strange words which Bernard Dorival had applied to his art – "haughty dryness of design, miserly economy of palette"[29] – are singularly inappropriate. Consider, for example, the *Book, Pipe and Glasses* (opposite) and *The Package of Quaker Oats* (page 51). Between them they typify the expressive flexibility of Gris' technique at this time. The main surfaces of the former picture have a tortoise-shell evenness and luminosity; the latter is richly encrusted and in some areas so heavily modeled in depth as to approach bas-relief. In color both images are the opposite of "miserly"; they are, on the contrary, fearless and vivid. Gris was too decisive a personality to have feared vulgarity, and the violet, rose, green and blue passages in *Book, Pipe and Glasses* achieve a memorable cacophony. In *Quaker Oats*, acidity of color becomes a virtue. Moreover, both these pictures confirm a point Kahnweiler has made repeatedly: that Gris, unlike Picasso and Braque at certain moments, never turned his back on chiaroscuro as an aid to spatial control. In both pictures the contours are reinforced by

[27] *Gris Letters*, bibl. 8, p. 15
[28] *Gris Letters*, bibl. 8, p. 27
[29] Dorival, Bernard, *Reproductions of Contemporary French Paintings*. Paris, Les Editions Nomis, n.d., p. 83
* Although Gris considered signing a contract with Rosenberg at this time, he did not actually do so until November, 1917. As part of the new arrangement, he held in reserve for Kahnweiler during the war, all the paintings completed before the spring of 1915. And upon Kahnweiler's return to Paris in 1920, Gris insisted that Rosenberg give up his exclusive rights to all of Gris' output, and divide his work with Kahnweiler, with each dealer assigned priorities on certain canvas sizes.

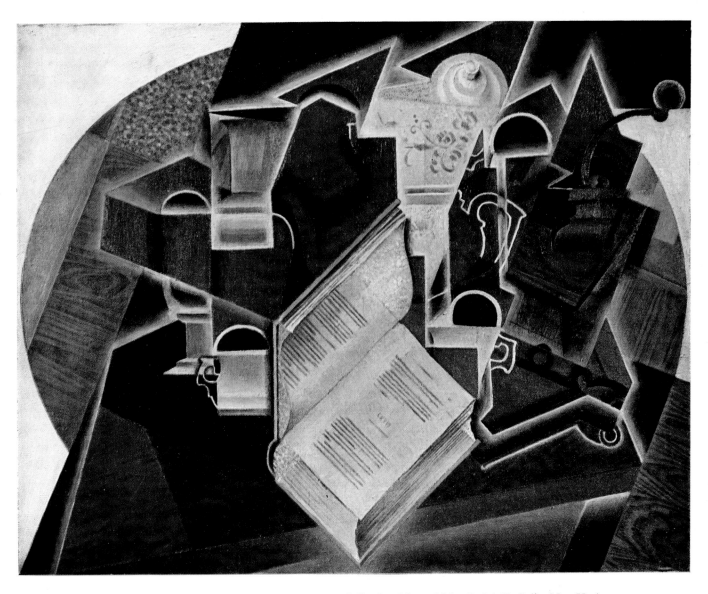

Book, *Pipe and Glasses*. March 1915. Oil on canvas, 28¾ × 36¼″. Collection Mr. and Mrs. Ralph F. Colin, New York

oppositions of light to shade, by those crisp contrasts which Gris admired in artists as different as Philippe de Champaigne and Corot.

At some point during 1915 Gris must have become especially interested in atmospheric effects. The interest is apparent in the magnificent *Still Life before an Open Window: Place Ravignan* (page 53), in which the street scene in the central background is bathed in a blue light. This light filters indoors in arbitrary shafts to deepen and solidify the forms of a complex still life that includes a bottle of Médoc, a fruit bowl, a book, a carafe and a copy of *Le Journal* – the newspaper which appears so often in Gris' art. The problem of combining an outdoor view with an interior scene has been faced by innumerable artists throughout the centuries. One doubts that among modern solutions any has been more original or compelling than that proposed by Gris in the *Place Ravignan*. The picture has a quiet dramaturgy, and once more it is necessary to insist that Gris at his best was not only a master of abstract calculation, but also a lyric poet.

The influence of poetry itself on Gris' painting is difficult to make precise, of course. We know that for his own pleasure and edification he translated poems by Mallarmé, and also by the Spanish elegant of the late sixteenth and early seventeenth centuries, Luis de Góngora y Argote. Gris' taste for Góngora's euphuistic verse might seem rather bewildering at first glance, considering his own direct mentality, but we will return to the subject later. Meanwhile, it is worth noting that his friend Lipchitz has explained to the writer that Gris was especially fond of anything he could define as "a human fabrication," that is, anything wholly contrived by man from the components of existing reality.[30] Among poets contemporary with him, Gris was closest to Pierre Reverdy, whose *Poèmes en Prose* and *La Guitare Endormie* he illustrated (in 1915 and 1919 respectively) and to whom he paid tribute in the *Still Life with Poem* (page 55). A parallel between Gris' printing and Reverdy's poetry has been suggested by several critics, but it would seem to consist of nothing more specific or revealing than a broad affinity of spirit.

As an artist Gris may have had greater years than 1915: 1914, for example, or 1917. Yet for sheer variety his work of 1915 is outstanding. The strange, lovely fluorescence of *The Check Tablecloth* (page 60) is a long cry from the splintered complexity of the *Still Life* (page 52). And in connection with the compositional arrangement of the former picture, mention should be made of Gris' passion for

[30] Lipchitz, Jacques. See footnote 8, p. 10.

50

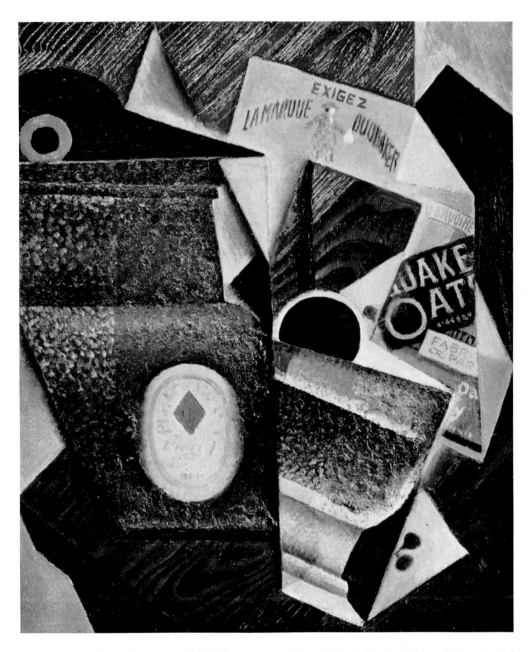

The Package of Quaker Oats. 1915. Oil on canvas, $17\frac{1}{2} \times 14\frac{1}{2}''$. Collection Mr. and Mrs. Daniel Saidenberg, New York

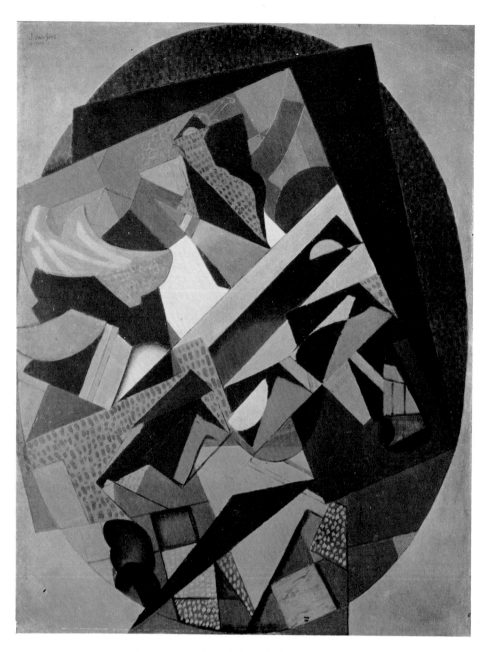

Still Life. June 1915. Oil on canvas, $45\frac{5}{8} \times 35''$. Galerie Louise Leiris, Paris

opposite: *Still Life before an Open Window: Place Ravignan*. June 1915.
Oil on canvas, $45\frac{5}{8} \times 35\frac{1}{8}''$. Philadelphia Museum of Art,
Louise and Walter Arensberg Collection. (Exhibited in New York only)

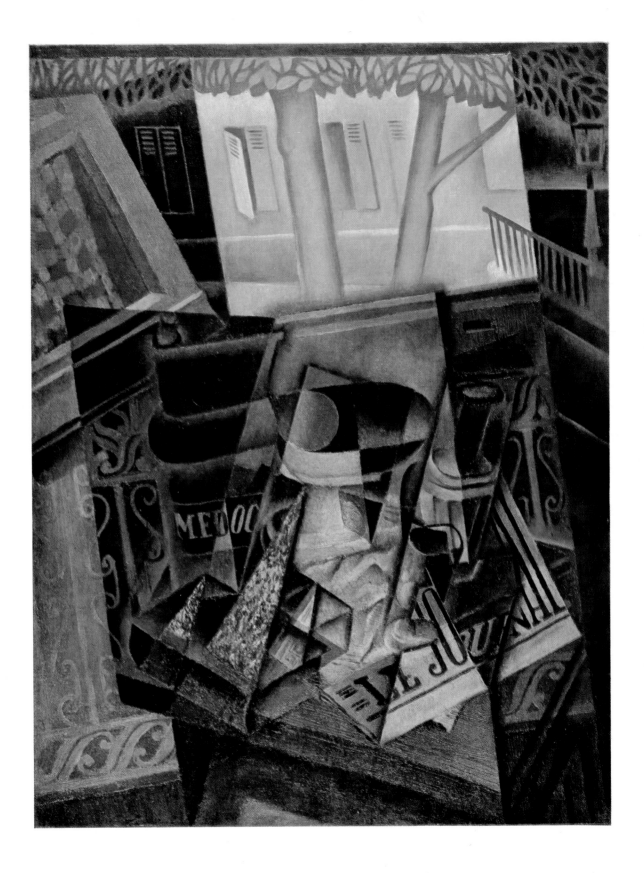

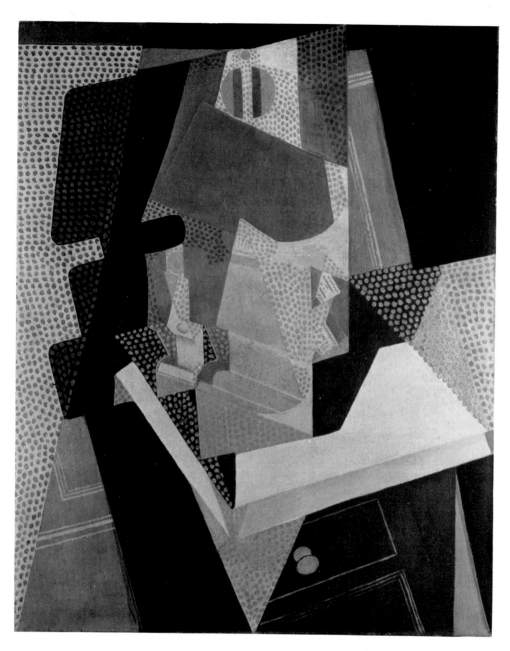

The Lamp. March 1916. Oil on canvas, $31\frac{7}{8} \times 25\frac{1}{2}''$. Philadelphia Museum of Art, Louise and Walter Arensberg Collection. (Exhibited in New York only)

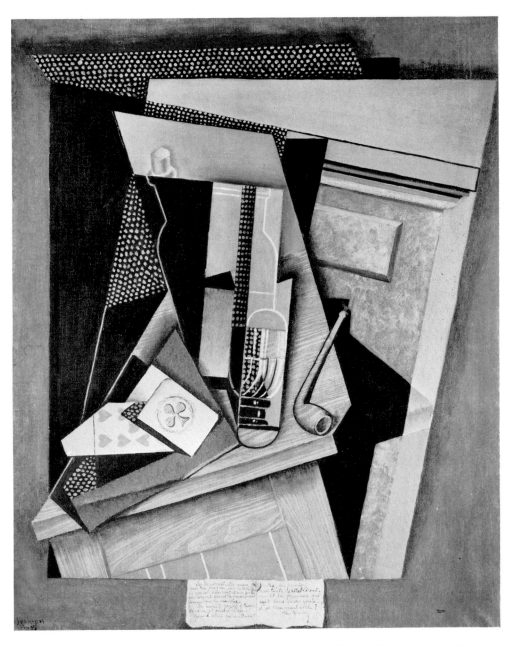

Still Life with Poem. Nov. 1915. Oil on canvas, $31\frac{7}{8} \times 25\frac{5}{8}''$. Collection Mr. and Mrs. Henry C. Clifford, Radnor, Pa. (Exhibited in New York, Minneapolis and San Francisco)

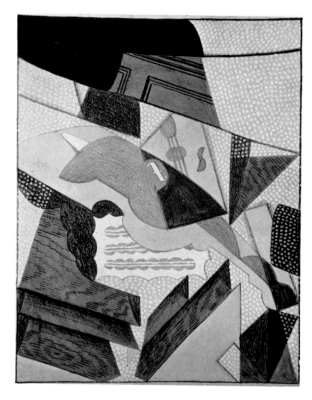

Violin. 1916. Gouache, $10\frac{1}{2} \times 8\frac{1}{2}''$. Mr. and Mrs. Isadore Levin, Detroit

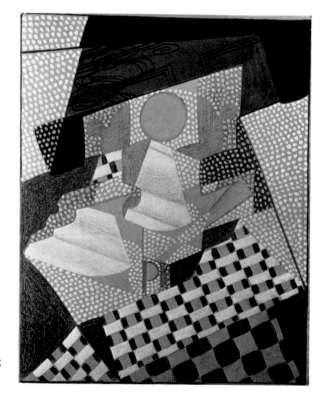

Soup Bowl. 1916. Gouache, $10\frac{1}{2} \times 8\frac{1}{2}''$. Saidenberg Gallery, New York

56

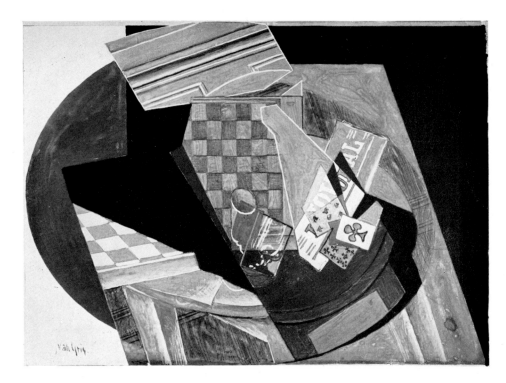

Chessboard. 1915. Gouache, 8¼ × 11¾″. Private collection, New York

triangles. Lipchitz has told the writer that Gris revered the triangle because it is "so accurate and endless a form." He added that once when he and Gris found a triangular-shaped drinking glass, the latter exclaimed: "You see we are influencing life at last!"[31] Gris' liking for triangular oppositions of form is evident, too, in *The Checkerboard* (page 59), with its adroitly shuffled planes and its counterplay between objects and their shadows.

1916: STILL LIFES AND FIGURE PIECES

In his still lifes of 1916 Gris alternated between insolence and sobriety in his use of color. From this and the previous year date several compositions in which objects are densely speckled, as though the painter had admired what Alfred Barr has called the "confetti-like stippling" in certain paintings by Picasso of

[31] Lipchitz, Jacques. See footnote 8, p. 10

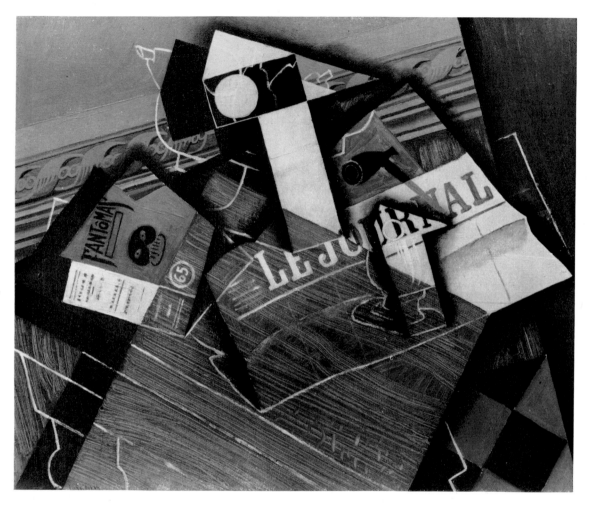

Still Life. 1915. Oil on canvas, 23½ × 28½″. Collection Heinz Berggruen, Paris. (Exhibited in New York only)

opposite: *The Checkerboard*. Sept. 1915. Oil on canvas, 36¼ × 28¾″.
The Art Institute of Chicago, gift of Mrs. Leigh B. Block,
and Ada Turnbull Hertle Fund. (Exhibited in New York only)

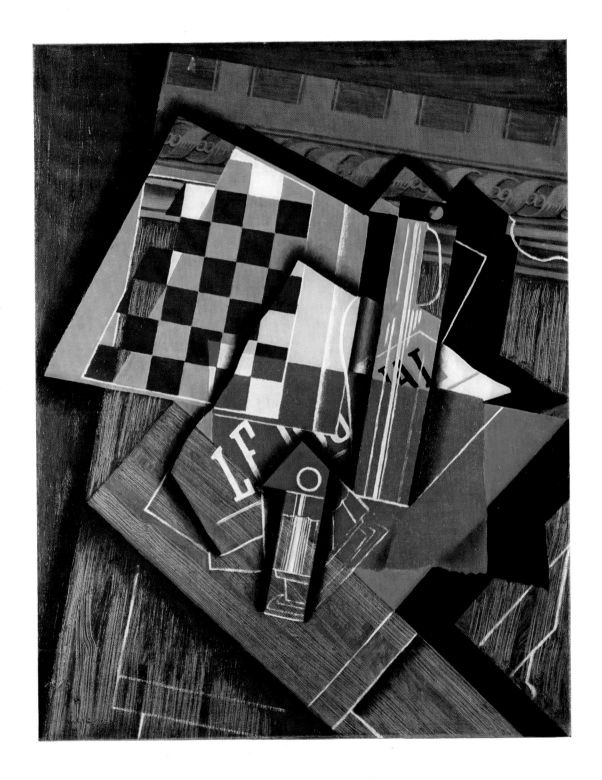

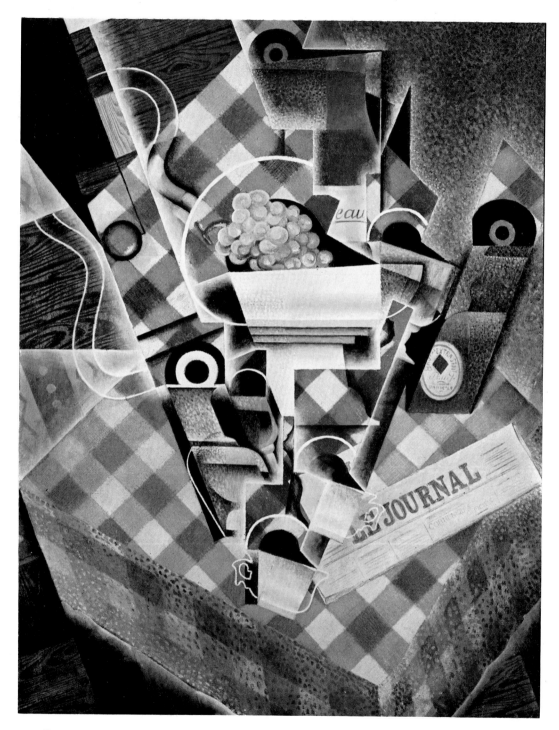

1913–14.[32] *The Lamp* (page 54) is a case in point, and Gris' gouaches of the time reflect the same preoccupation (page 56). But from these lively works he turned to the serenity of the little *Fruit Dish, Glass and Newspaper* (page 65), with its subtle restraint of wood graining. And in July he completed one of the absolute master-works of his career – *The Violin* (page 63). The picture's subdued contrasts of brown, black, white and gray give it a transcendental intensity, a kind of mystic purity which once more proves how persistent was the effect of Gris' atavistic sources. However French his taste became, he remained the heir to Zurbarán. His Spanish ecstasy and pessimism of temperament are apparent, too, in the *Still Life with Fruit Bowl* (page 66) which he presented soon after it was completed to Henri Matisse – a fact which somehow signalizes the contrast between Gris' ascetic vision and the perennial *bon gout* of France at a very high level.

Two other still lifes of 1916 are the *Still Life with Newspaper* and the *Still Life with Playing Cards* (pages 62 and 67). Gris by now had entered what Kahnweiler has called his "architectural" period and described as follows: "Stately and firm, his paintings had become the 'flat colored architecture' of which he talked. Everything was restored to the flat surface; the objects inscribed thereon were emblems which he invented, true 'concepts.' He abandoned multiple descriptions of objects. Line and color were more closely associated, for his pre-occupation with 'local' color apparently diminished. The emblems themselves rise one above the other architecturally, and they are controlled by the general structure, which causes their 'distortion' and 'discoloration.' It might almost be more accurate to say that it is the architecture – the whole construction – that governs their form and their color."[33]

In the summer of 1916 Gris and his wife went to Beaulieu near Loches, in the province of Indre-et-Loire. The landscape there seems to have tempted him as a subject, though in a letter of September 21st to André Level he confessed that he found landscape painting discouraging – "it is all so beautiful that I don't know how to manage without spoiling it."[34] Only one landscape painted at Beaulieu

[32] Barr, Alfred H. Jr., *Picasso: Fifty Years of His Art*. New York, Museum of Modern Art, 1946, p. 83
[33] Kahnweiler, bibl. 37, p. 91
[34] *Gris Letters*, bibl. 8, p. 40

opposite: *The Check Tablecloth*. 1915. Oil on canvas, 45¾ × 35".
Collection Dr. W. Loeffler, Zurich. (Not in exhibition)

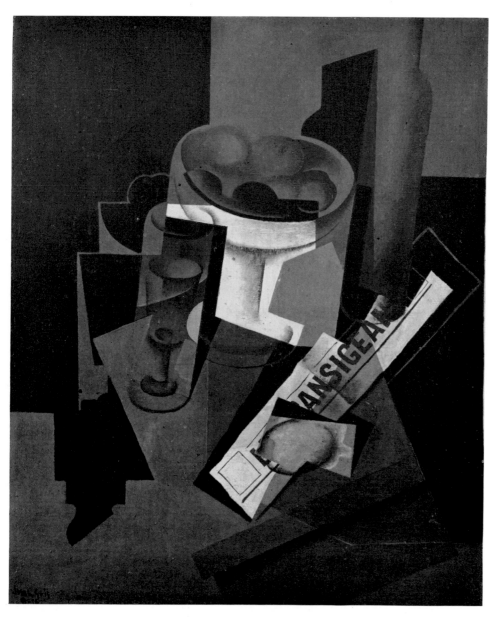

Still Life with Newspaper. Aug. 1916. Oil on canvas, $28\frac{3}{4} \times 23\frac{5}{8}''$. The Phillips Collection, Washington, D.C.

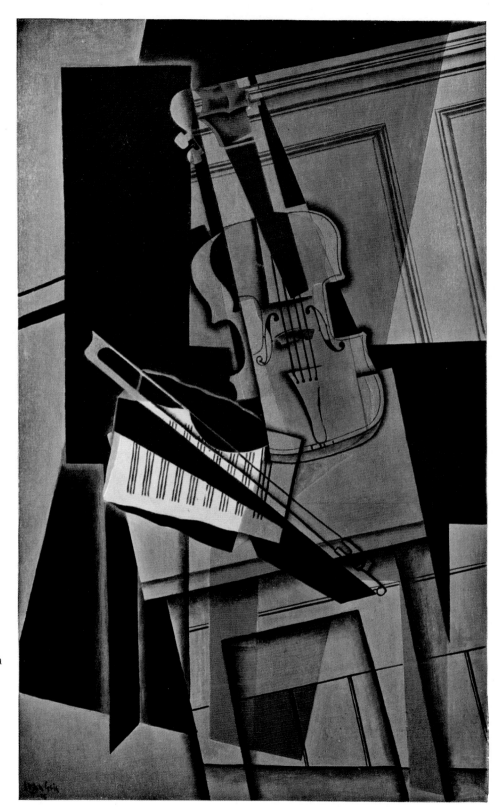

The Violin. 1916. Oil on wood, 45½ × 29″. Kunstmuseum, Basel. (Not in exhibition)

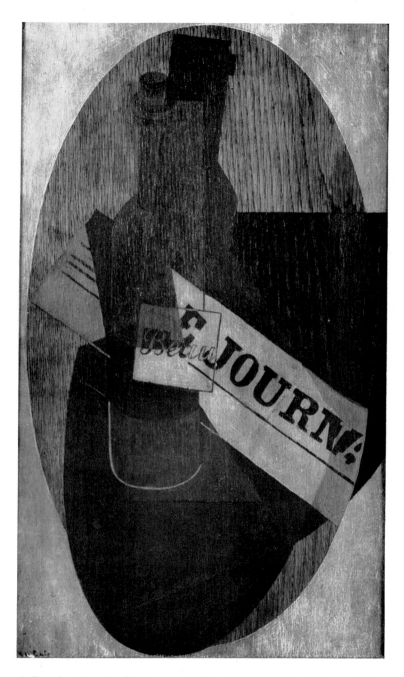

Still Life. 1916 (?). Oil on wood, 20½ × 13″. Collection Mr. and Mrs. Bernard J. Reis, New York

opposite: *Composition*. 1916. Pencil, $15\frac{1}{8} \times 10\frac{3}{4}''$. Private collection, New Canaan, Conn.

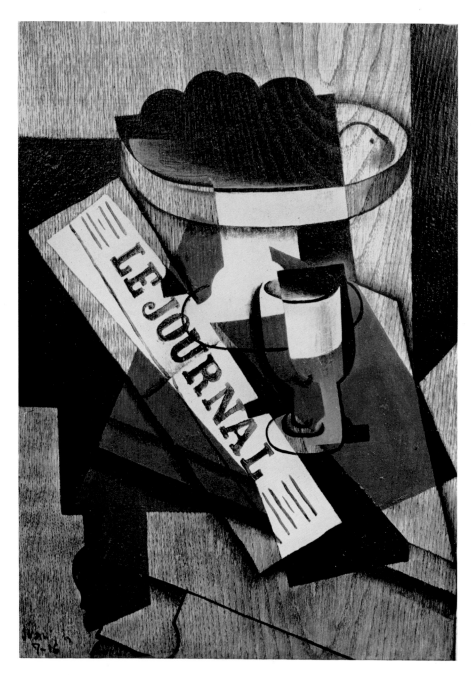

Fruit Dish, Glass and Newspaper. July 1916. Oil on wood, $21\frac{5}{8} \times 15''$. The Museum of Modern Art, New York, gift of Mrs. John D. Rockefeller, Jr.

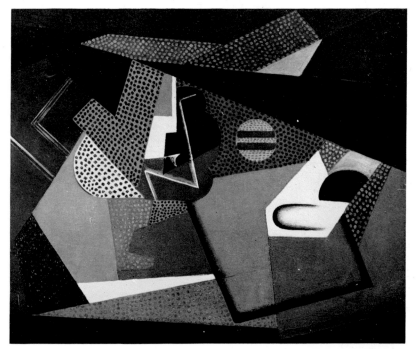

Still Life. July 1916. Oil on wood, $25 \times 31\frac{1}{2}''$. Collection Mrs. Albert H. Newman, Chicago

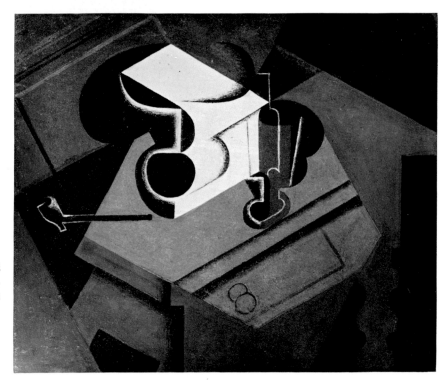

Still Life with Fruit Bowl. 1916. Oil on wood, $23\frac{3}{4} \times 28\frac{7}{8}''$. Collection Mr. and Mrs. Joseph Pulitzer, Jr., St. Louis. (Exhibited in New York only)

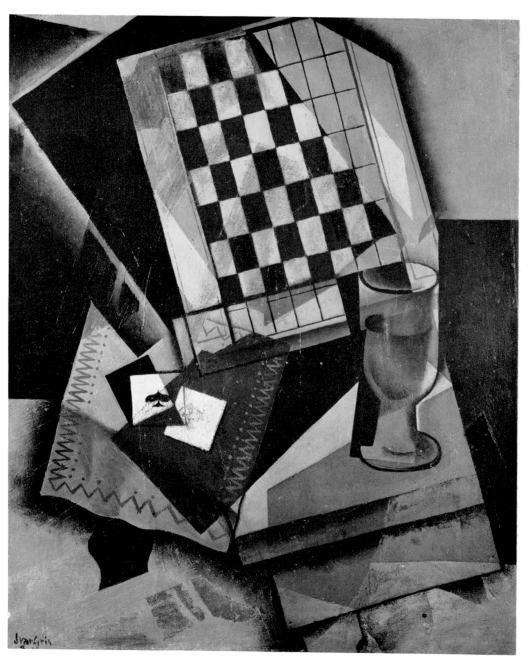

Still Life with Playing Cards. 1916. Oil on canvas, 27¾ × 22¾″. Washington University, St. Louis

at this time has survived. On the other hand, he completed there in the autumn three of his finest figure pieces, presumably the first he had undertaken since his early years as a cubist. The first of these, executed in September, is a free interpretation of one of Corot's many versions of the *Woman with a Mandolin* (below). Like Picasso and other painters who were his contemporaries, Gris felt a need at times of renewing himself through direct, if quite arbitrary transcriptions of the work of earlier artists; in 1916 he also made a drawing after Cézanne's self portrait (page 118), and two years later painted a picture based on the latter's portrait of Mme Cézanne. Gris' *Woman with a Mandolin* (opposite) is a not unworthy pendant to Corot's elegiac image, and this and other Gris figure pieces of 1916–17 may well have had an influence on some of the painter's colleagues, among them Braque, as previously noted.

The *Woman with a Mandolin* was succeeded by two portraits of the artist's wife, Josette, whose family had come from Beaulieu. One of these is three-quarter length; the other (page 71) a head and bust. The latter follows the larger image in all important facial essentials and probably was a preparatory study for it. In both cases the portrait exemplifies the architectural preoccupations to which Kahnweiler has referred in discussing Gris' work of 1916–19. The

Corot: *Woman with a Mandolin*. 1860–65. Oil on canvas, 20¼ × 14½″. City Art Museum of St. Louis. (Not in exhibition)

68

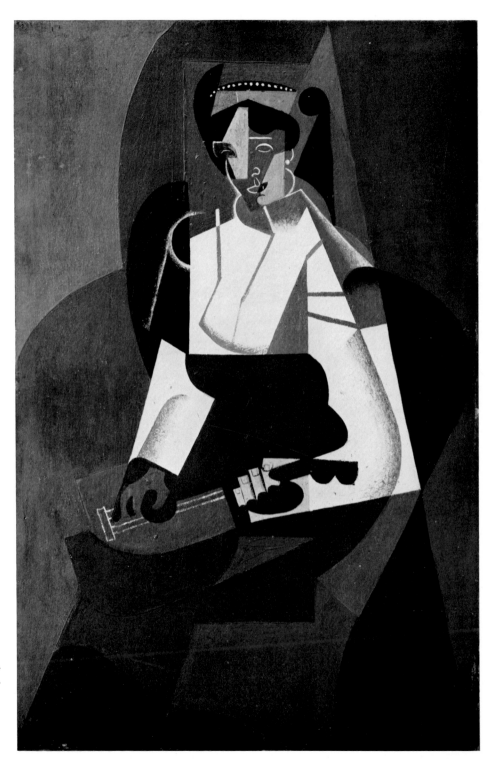

Woman with a Mandolin (*after Corot*).
Sept. 1916. Oil on plywood, $36 \times 23\frac{1}{2}''$.
Kunstmuseum, Basel

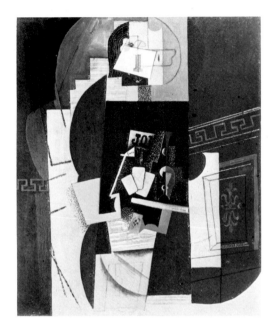 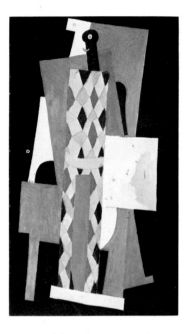

left: Picasso: *Card Player*. 1913–14. Oil on canvas, 42½ × 35¼″. right: Picasso: *Harlequin*. 1915. Oil on canvas, 72¼ × 41⅜″. Both the Museum of Modern Art, New York, acquired through the Lillie P. Bliss Bequest. (Not in exhibition)

image is deliberately flat by comparison with most earlier pictures by the artist, local color has been suppressed and conventional modeling through shading confined to contours of Josette's left shoulder and the back of her head. The contrasting areas of light grey, dark grey, buff, black, brown and white are masterfully placed. And if the basic concept of the picture owes something to Picasso (one thinks at once of such works by the latter as the *Card Player* and the celebrated *Harlequin* of 1915 (above), nevertheless the *Portrait of Josette* remains a personal achievement. Its sobriety and calm reflect Gris' temperament, which was vastly different from that of Picasso. The difference may be felt in the two artists' handling of facial accents. Gris lacked his countryman's enlivening humor. Whereas in Picasso's *Harlequin* the figure's head is witty, in Gris' *Josette* it is solemn and quiet. Yet if Gris was far less ebullient than Picasso, his conscientious purity brought its own rewards, as in this heraldic image.

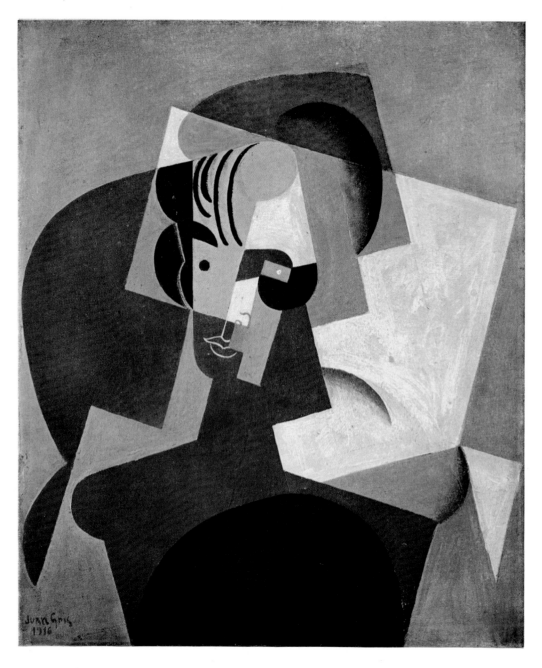

Portrait of Josette. 1916. Oil on wood, 21⅝ × 17¾″. Hermann and Margrit Rupf Foundation, Bern

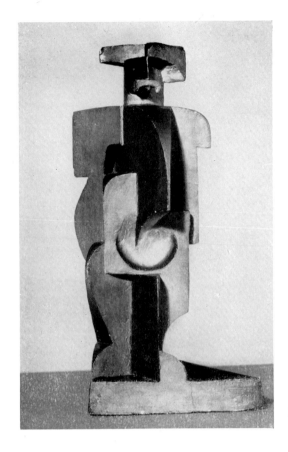

Harlequin. 1917. Plaster, carved and painted, 21½″ high.
Philadelphia Museum of Art, A. E. Gallatin Collection

1917: THE SCULPTURED HARLEQUIN

At the end of October or early in November, 1916, Gris and his wife returned to
Paris. There he seems to have shared for a time a prevailing if ill-founded belief
that the war would soon be over. On December 23rd he wrote to Maurice Raynal:
"This time perhaps it will be peace at last."[35] He was greatly interested in the
arrangements for testimonial dinners to celebrate the recovery from their war
wounds of Apollinaire and Braque (a temporary recovery in the former's case,
alas). Though Gris enjoyed the dinners in honor of his friends, he was always

[35] *Gris Letters*, bibl. 8, p. 43

tormented when not working, and on January 18th, 1917, he wrote Raynal ruefully: "Are you working at all? I'm not getting much done as a result of all these festivities. I've become rather lazy."[36] Soon it was even more difficult for him to work, due to the extreme cold in Paris and the coal shortage. Yet at this time, with the help of his friend Lipchitz, he executed the only true sculpture of his career – the *Harlequin* in painted plaster (opposite).

Since Lipchitz was so close to Gris at this time, his words on the painter are of special interest. "Gris was not," said Lipchitz, "a completely gifted man, but he had a measure within himself and a mystical will to work. Above all he was a superb human being. He had a terrible inferiority complex at times. As an example, he used to despair of being able to achieve what in Braque's art he called '*la ligne tremblante*.' He said that he himself could manage such effects only by drawing one small section of a contour at a time, slowly, painstakingly, in contrast to Braque's swift skill."[37] The story is astonishing, considering the apparent certainty of many Gris drawings (pages 76 and 90).

Lipchitz went on to say: "Gris was very shy and modest. Once at an elaborate private dinner, he did not get enough to eat and so turned to the butler timidly and whispered, '*un sou de pain, s'il vous plait*' as though he were ordering bread in a cheap restaurant."[38] And in 1944 for the catalogue of a Gris exhibition at the Buchholz Gallery in New York, Lipchitz put down in writing some interesting evidence as to Gris' probity as an artist: "I remember in 1916, Juan Gris was living at the quaint 'Place Emile Goudot,' Montmartre, in the disused *lavoir* still haunted by the spirit of Picasso and others who lived there before him. It was broad daylight when I arrived; Juan was cleaning his paint brushes, his day's work over. On the easel was a painting so perfect, so splendid, to my mind so complete, that in my youthful enthusiasm I cried out, 'Juan, for Heaven's sake don't touch it any more.' He turned on me pallid, threatening, shouting, 'What do you mean by that? Are you fooling? Can't you see the moustache is not finished?' Call to mind the aspects of his paintings of that period!"[39] The picture has not been identified, and may have been destroyed by the artist. But the anecdote throws light on Gris' extraordinary dedication to his art – and to perfection.

Now back to the sculptured *Harlequin*. Lipchitz reports that Gris began by

[36] *Gris Letters*, bibl. 8, p. 45
[37] Lipchitz, Jacques. See footnote 8, p. 10
[38] Ibid.
[39] Buchholz Gallery, bibl. 64 (1944), Lipchitz preface

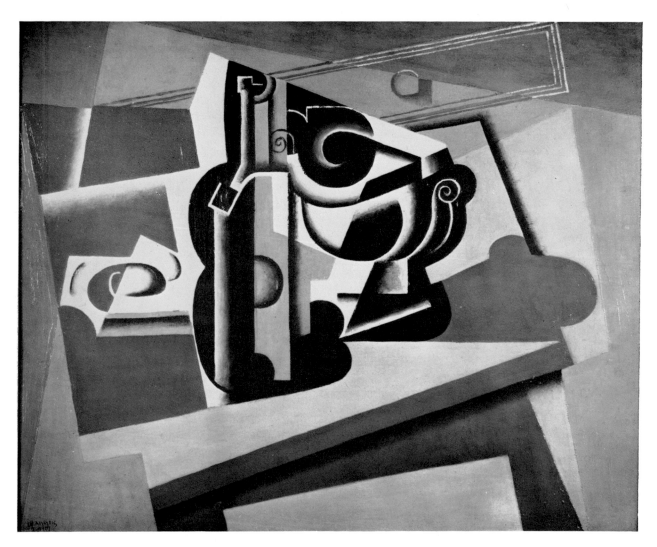

Still Life. Feb. 1917. Oil on wood, 29 × 36″. The Minneapolis Institute of Arts

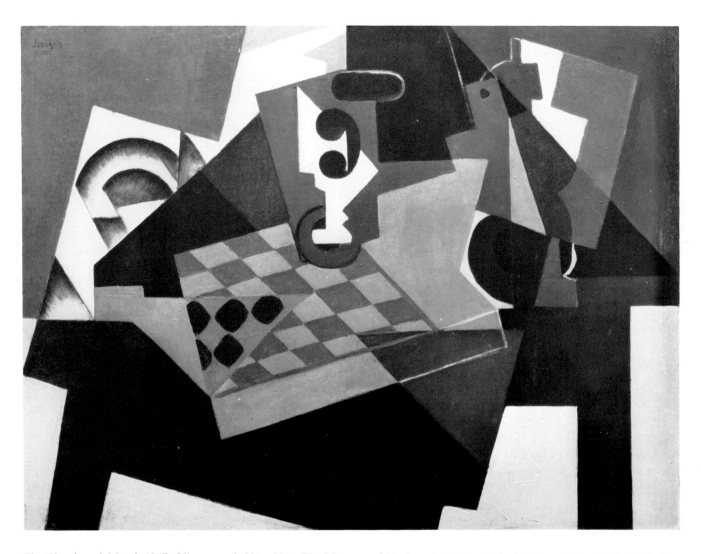

The Chessboard. March 1917. Oil on wood, 28¾ × 39⅜″. The Museum of Modern Art, New York, Purchase 1939. (Exhibited in New York only)

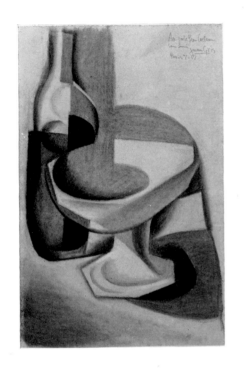

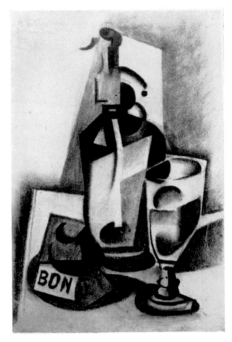

left: *Fruit Dish and Bottle.* July 1917. Conté, crayon 18¾ × 12¼". The Museum of Modern Art, New York, acquired through the Lillie P. Bliss Bequest

right: *The Siphon.* July 1917. Conté crayon, 18¾ × 12½". Philadelphia Museum of Art, A. E. Gallatin Collection

making with plaster and armatures a *section d'or* on which the former gave him technical help. Gris then worked and reworked the plaster until it assumed its present form. Finally, the plaster surfaces were painted with subdued colors. Gris must have thought of the sculpture as a closely related extension of his easel paintings. Yet in view of the very considerable quality of the *Harlequin*, it seems curious that he was never again tempted to try his hand at sculpture. Perhaps the answer lies in his fanatical single-mindedness as an artist. As will appear in the brief discussion of his work for Diaghilev's ballet, he was uneasy with a project which took him away from his painting for long. It is true that in 1923 he executed a few figures in painted metal. But these, according to Kahnweiler, "he considered as playthings and gave them away to friends."[40] He seems, on the other hand, to have felt some pride in the *Harlequin*, and it is difficult to believe that he thought it too close to the cubist sculptures of other artists. It remains an individual and by no means negligible work of art.

[40] Kahnweiler, bibl. 37, p. 108

In February, 1917, Gris completed the wonderfully severe Minneapolis *Still Life* (page 74), in which the two principal still-life elements, a bottle and an elaborately curvilinear fruit bowl, are placed near the middle of the wooden table whose drawer, complete with rounded knob, appears as a detached form in the background. The image again typifies Gris' interest in a counterplay between objects and their shadows and also his passion for using comparable shapes for objects of differing identities, as when an incomplete circle is here repeated from left to right throughout the composition. In its more or less central massing of still life against broad and abstract surrounding areas, the picture is related to the *Still Life with Fruit Bowl* (page 66) which Gris had painted the year before and presented to Henri Matisse.

From the relative simplicity of the *Still Life* Gris turned in the spring of 1917 to the much more complex and extraordinarily poetic *Chessboard* (page 75). The picture is unusual, but by no means unique, in its assembly of unrelated and enigmatic objects. Indeed, some of these objects are hard, when not impossible, to decipher in terms of the everyday reality from which Gris' art customarily took its point of departure. In *The Chessboard* we may assume that the exclamation-point form in the center has its remote genesis in the sound holes of violins. But what is the jagged, light shape against which it is placed? And what is the true nature of the curved and triangular forms placed at the left against a paler ground? No answer can be given with certainty (nor can we be positive as to the identity of the long, triangular objects near the bottom of the *Place Ravignan*, page 53, painted two years before).

Perhaps at this juncture in his career Gris wished, if temporarily, to move away from reality as the cubists understood it and to make use of metaphysical conceits. Perhaps, too, it was at this time that he was most engrossed in the poetry of Góngora. This poetry did not come back into international favor until roughly the third centenary of the poet's death in 1625, but Gris as a fellow-Spaniard very likely appreciated its virtues somewhat earlier. In any case, J. M. Cohen might be speaking of certain Gris paintings of 1917 when he referred to Góngora's "refinements of allusion and . . . dependence on antithesis and parallelism," as in the famous lines: *Cuando pitos, flautas/cuando flautas, pitos.*[41]

Cohen goes on to say: "His [Góngora's] imagery, with its strong colors,

[41] [When you expect whistles, it's flutes;/when you expect flutes, it's whistles.] Cohen, J. M., ed., *Penguin Book of Spanish Verse*. Harmondsworth, England, 1956, p. 210

presents an artificial landscape in which objects are often described only by a single quality."[42] A relationship to Gris' art suggests itself here though, as in the case of the poetry of Gris' friend and contemporary, Pierre Reverdy, its importance should not be exaggerated.

Oddly enough, the change toward complication in Gris' paintings of 1917 took place at a moment when the artist looked backward to re-examine his own early work as a cubist. The inexplicable objects at the left of *The Chessboard*, though new in inventiveness of iconographical identity, are somewhat comparable in handling to the windswept forms that had been Gris' personal contribution to cubism in his paintings of 1911 and 1912. One therefore assumes that the painter was unusually introspective during the early months of 1917 and that he may have wished both to review the beginnings of his mature art and to extend his still-life vocabulary through the inclusion of enigma and paradox. Certainly the transposition of almost identical appearance from a given object to a second or third normally unrelated one – a transposition which fascinated Gris as it had fascinated Góngora before him – takes on a new character in *The Chessboard*. If the picture is in a sense more troubling than many of Gris' paintings, it is surely among his most inspired.

During the spring of 1917 Gris was abnormally depressed, and on June 16 wrote Maurice Raynal: "You can't imagine the feelings of gloom and disgust to which I have been a prey for some time now . . . Sometimes these periods last for weeks, sometimes for months."[43] He added: "Paris is not much fun I assure you despite the sun and the arrival of General Pershing."[44] Yet he continued to work with skill and devotion, and from the latter part of the year date a number of thoroughly remarkable pictures. They range in style from the stern, enameled simplicity of the *Landscape* (page 82) to the zigzag complexity of the *Violin and Newspaper* (page 80), in which the planes are as intricately adjusted, one behind the other, as the sails on a clipper ship. In August he completed *The Sideboard* (page 79), one of the most superbly controlled of all his works, a picture in which the lighting approaches atmospheric naturalism, though its forms are succinct and abstract. And then very late in the year his color and textures became more sumptuous, notably in the *Fruit Bowl on Checkered Cloth* and the *Still Life* (pages 83 and 84).

Braque had returned in the fall to his old studio in the Hotel Roma, Paris,

[42] Cohen, J. M., ed., *Penguin Book of Spanish Verse*. Harmondsworth, England, 1956, p. xiv
[43] *Gris Letters*, bibl. 8, p. 50 [44] *Gris Letters*, bibl. 8, p. 51

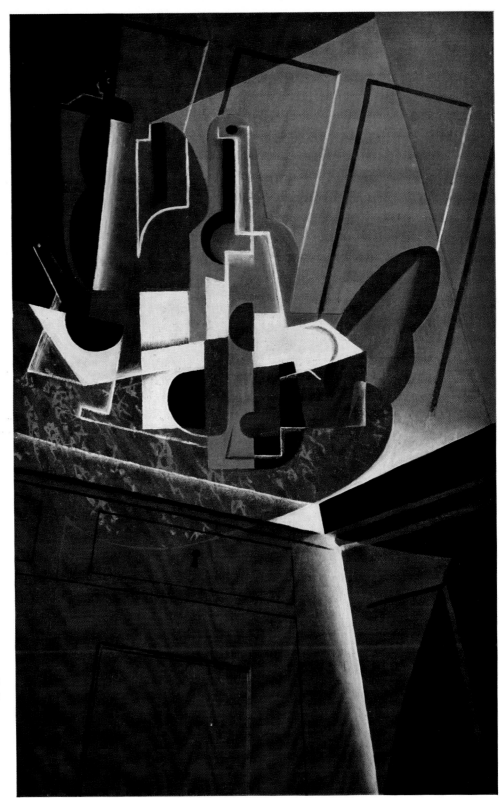

The Sideboard. Aug. 1917. Oil on plywood, 45¾ × 28¾″. Collection Nelson A. Rockefeller, New York

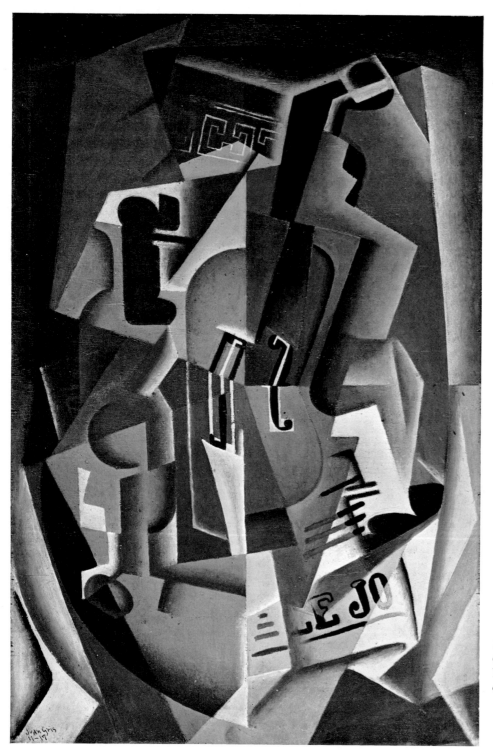

Violin and Newspaper. Nov. 1917. Oil on wood, $36\frac{1}{2} \times 23\frac{1}{2}''$. Private collection, New York. (Exhibited in New York only)

and Henry Hope has reported after conversations with the artist: "Braque was glad to see Juan Gris, and he liked Gris' recent paintings."[45] The two men apparently saw each other frequently during this period, and it is probable that Gris looked up to his elder colleague in cubism, whose fluency he had always admired, as previously noted. In any case, there was at this time a strong affinity of spirit between Braque and Gris. In the autumn of 1917 Braque painted his fine *Woman with a Mandolin*; in December Gris resumed the figure painting to which he had turned before, especially in 1916, and completed the resplendent *Harlequin with a Guitar* (page 86). He was seldom to do anything more impressive in this genre. The picture's alabaster surface and intensely Spanish color are unusually authoritative and more than justify Gris' modest words to Kahnweiler: "I am a good workman," or again, "My work may be bad 'great painting,' but at any rate it is 'great painting.' "[46] With pictures such as the *Harlequin with a Guitar* and *The Sideboard*, both of 1917, Gris takes his place as the peer of Picasso and Braque. Indeed, with three proponents of such immense talent – and not forgetting Léger in addition – cubism could hardly have failed to win international respect as one of the great art movements of our century.

1918–1919: THE END OF THE WAR: STILL LIFES, LANDSCAPES, FIGURES

In April, 1918, Gris and his wife left Paris for Beaulieu, and on the 27th of that month the painter wrote Raynal: "I have come here more to work than to rest, and I can assure you that I'm getting a good deal done. I couldn't get anything done latterly in Paris because I was so on edge."[47] The statement seems odd in that in Paris in March Gris had completed his majestic interpretation of Cézanne's portrait of Mme Cézanne and in February had painted the enchanting *Violin and Glass* (page 89), with its jagged cohesion and deft variety of form. Moreover, the *Still Life with Fruit Bowl* (page 88) belongs to the same period and must be considered one of Gris' finer works. Its green newspaper – *Le Journal*, as so often in Gris' iconography – is handsomely balanced against surrounding passages of blue, white and brown. Its companion piece, the Lefèvre *Newspaper and Fruit Bowl* (page 91), dated March, 1918, is no less inspired.

[45] Hope, Henry R., op. cit. p. 74

[46] Kahnweiler, bibl. 37, p. 93. *Cf. Gris Letters*, bibl. 8, p. 66: "I hope that ultimately I shall be able to express very precisely, and by means of pure intellectual elements, an imaginery reality. This really amounts to a sort of painting which is inaccurate but precise, just the opposite of bad painting which is accurate but not precise."

[47] *Gris Letters*, bibl. 8, p. 53

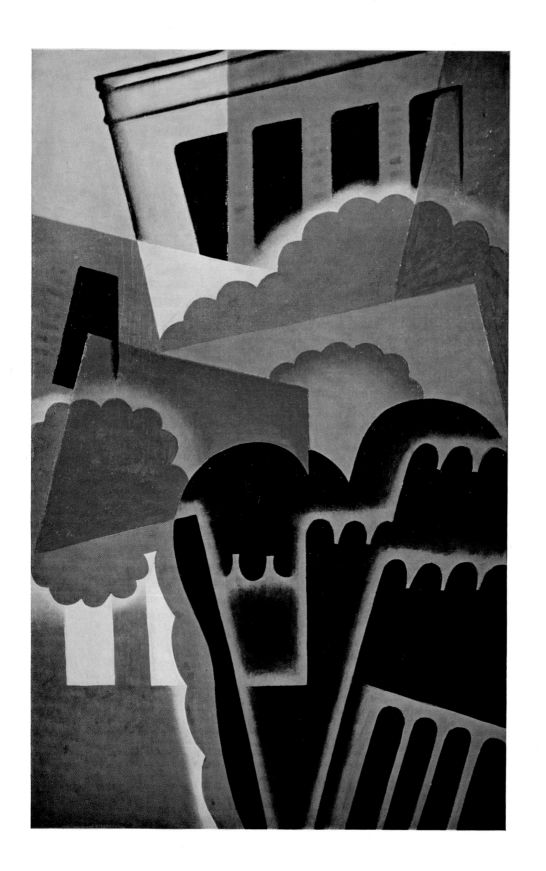

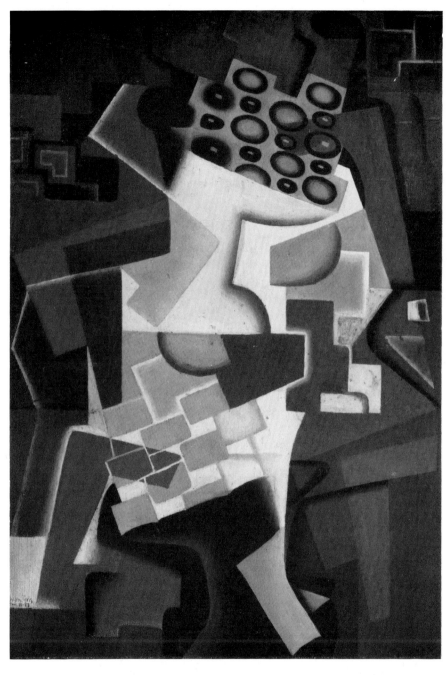

Fruit Bowl on Checkered Cloth. Nov. 1917. Oil on wood, 31¾×21⅜″. The Solomon R. Guggenheim Museum, New York. (Exhibited in New York only)

Opposite: *Landscape.* July 1917. Oil on wood, 45¼×28½″. Saidenberg Gallery, New York

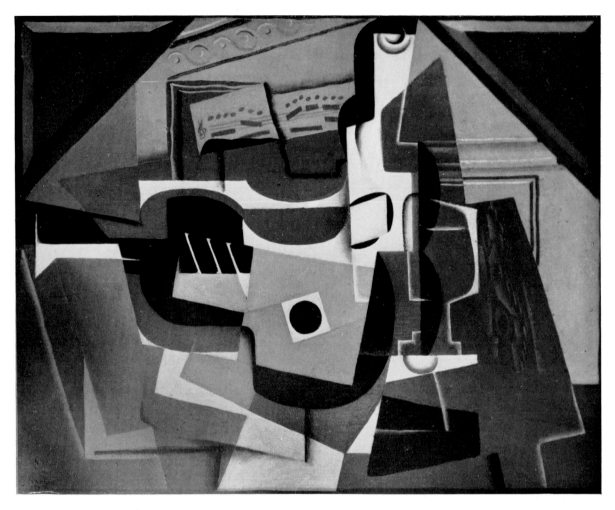

Still Life. Dec. 1917. Oil on canvas, $28\frac{7}{8} \times 36\frac{1}{2}''$. Private collection, New York

Both of the two pictures just mentioned reaffirm Gris' devotion to craft which Lipchitz, who was with the painter at Beaulieu at this point, has described as making up in "mystical will to work" what Gris may have lacked in headlong talent. But perhaps the clearest description of the latter's monastic absorption in painting was given in a letter of August 25th, 1919, to Kahnweiler: "I would like to continue the tradition of painting with plastic means while bringing to it a new aesthetic based on the intellect. I think one can quite well take over Chardin's means without taking over either the appearance of his pictures or his conception of reality. Those who believe in abstract painting seem to me like weavers who think they can produce a material with threads running in one direction only and nothing to hold them together. When you have no plastic intention how can you control and make sense of your representational liberties? And when you are not concerned with reality how can you control and make sense of your plastic liberties?"[48] The latter makes certain that Gris would have been first of all a *painter*, in any epoch, in any style. As to Chardin, there are passages in both the *Still Life with Fruit Bowl* and the *Newspaper and Fruit Bowl* which that humble yet incalculably proud eighteenth-century master would in all probability have approved.

At Beaulieu Gris painted several landscapes with architecture and in July wrote to André Level: "I am trying my hand at landscape, which doesn't seem to come off, and so I console myself by doing an occasional still life which satisfies me."[49] Despite the artist's own doubts, the *House in a Landscape* (page 92) is an estimable work; its alternation of broad, solid passages with speckled interruptions is subtle and convincing. Moreover, the highlighting on the chimney of the house again proves Gris' faith in those quite literal atmospheric effects which so many of his contemporaries had discarded entirely. It was not naïvete which led Gris to insist on the occasional virtues of reality, as in the letter quoted above; it was a profound conviction that art must be something more than "abstract."

During 1918 Gris executed several of his most commendable figure pieces, among them *The Man from Touraine, The Miller, The Harlequin at a Table* and *The Guitarist*; the last two named were completed in October, and the following month Gris and his wife returned to Paris. The end of the war was near at last, and the artist was in an unusually cheerful mood about his work. On September 24th he had written Paul Dermée: "I have just this minute returned from the

[48] *Gris Letters*, bibl. 8, pp. 65, 66 [49] *Gris Letters*, bibl. 8, p. 56

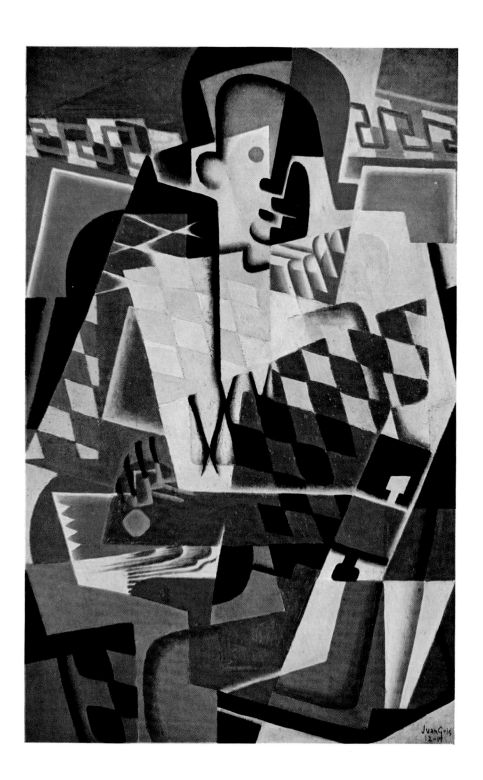

station after accompanying the Lipchitzes who were leaving. One by one they go and gradually Beaulieu is getting empty, but I have not yet thought of taking my departure. I'm immersed in a dream about such important work that I think of nothing else. Time and space only exist in my life as ideas or as elements of my work."[50] His optimism about his recent pictures was not ill-founded. In April, 1919, he held a one-man exhibition at Léonce Rosenberg's gallery. In his own words, "My exhibition . . . had a certain amount of success. There were about fifty pictures painted in 1916, '17 and '18. They looked rather well as a group and a lot of people came. Yet I don't really know how much they liked it, for there is so much admiration for the sheerest mediocrity; people get quite excited about displays of chaos, but no one likes discipline and clarity. The exaggerations of the Dada movement and others like Picabia make us look classical, though I can't say I mind about that."[51]

Gris' own pictures tended in 1919 to become more severe and deliberately flat as in the *Harlequin* and the *Guitar and Fruit Bowl* (pages 98 and 94). At the same time they show a rather swift assurance by comparison with certain earlier works. Yet oddly enough, through one of those abrupt reversals of mood which characterized Gris throughout his life, he now had grave doubts about his technical ability: "In fact owing to my lack of experience I find that, whereas I may have control over my feelings and my mind, I do not always have the same control over the tip of my brush. My work in its present stage can be compared with those pictures of Seurat in which the severity and the emptiness are the results of inexperience and not of incompetence."[52] He goes on in the same letter (September 3rd, 1919) to reproach Picasso for a worldliness to which he himself may have aspired at times and which, as we shall see, eventually involved him in commissions for Diaghilev's ballet: "Picasso produces fine things still when he has the time between a Russian ballet and a society portrait."[53] Nevertheless, there can be little doubt that it was Picasso's sporadic return to an Ingres-like realism in his drawings of 1915–23 which led Gris to try his hand at working in this vein, as in the drawing of his friend, Max Jacob (page 96).

For the most part, however, Gris remained faithful to synthetic cubism during

[50] *Gris Letters*, bibl. 8, p. 58
[51] *Gris Letters*, bibl. 8, p. 65
[52] *Gris Letters*, bibl. 8, p. 67
[53] Ibid.

pposite: *Harlequin with a Guitar*. Dec. 1917. Oil on wood, 39¾ × 25½″.
Collection Mr. and Mrs. Alex L. Hillman, New York

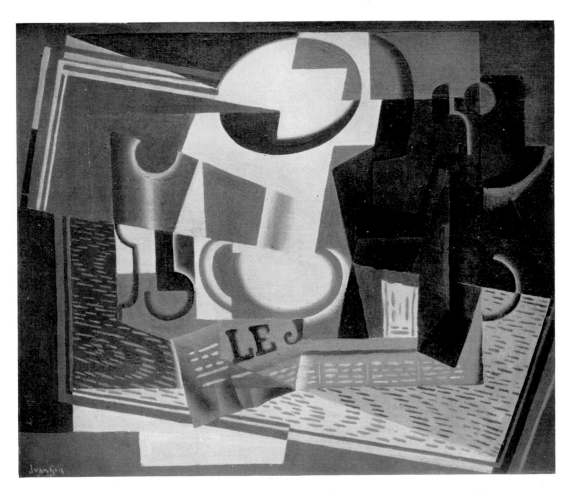

Still Life with Fruit Bowl. Feb. 1918. Oil on canvas, 21¼ × 25½″. Collection Hermann Rupf, Bern

opposite: *Violin and Glass*. Feb. 1918. Oil on canvas, 31¾ × 25½″. Collection Mr. and Mrs. George Henry Warren, New York

88

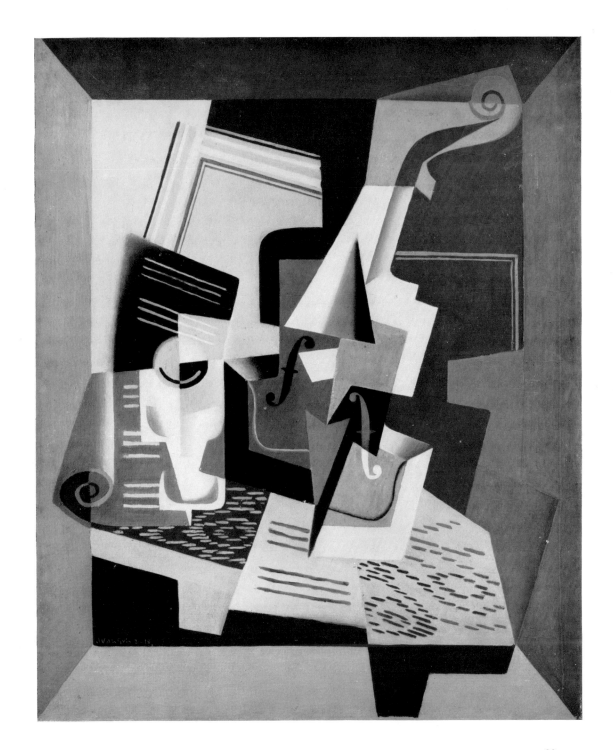

89

left: *Still Life*. May 1918. Pencil, 18⅛ × 11⅝". Rijksmuseum Kröller-Müller, Otterlo. above: *Still Life*. 1918 (?). Crayon, 14⅛ × 20⅞". Rijksmuseum Kröller-Müller, Otterlo

opposite: *Newspaper and Fruit Bowl*. March 1918. Oil on canvas, 36¼ × 25⅛". Collection André Lefevre, Paris

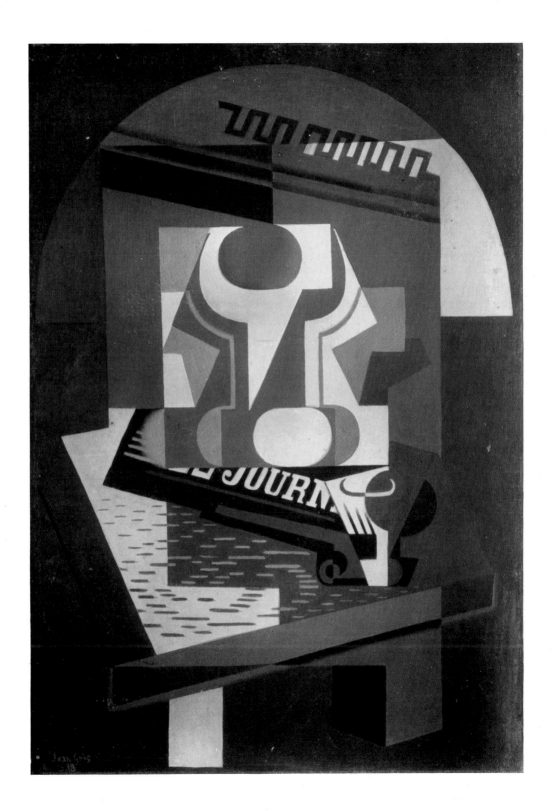

1919 and in that year, as noted, painted the *Guitar and Fruit Bowl* and the *Harlequin*. The latter picture illustrates with rare clarity the stylistic device herein mentioned frequently as one of Gris' most persistent preoccupations: the blending of unrelated iconographical elements by close allusions of contour and over-all shape. In the *Harlequin* the figure's legs could be the legs of the table against which the harlequin stands. The picture also exemplifies Gris' interest in depicting simultaneously two aspects of the human face – full face and profile. This principle of "simultaneity," a favorite device of the cubists, was first revived by Picasso, as Alfred Barr has pointed out, in his celebrated *Demoiselles d'Avignon* of 1907, wherein profile noses are given to full-face heads. Barr adds that simultaneity "appears again and again in his [Picasso's] cubist and post-cubist work . . ."[54] Gris, on the contrary, was more cautious and restrained in his use of double images. The dark profile which bisects the rounded, frontal view of the head in the *Harlequin* is a far more drastic solution of the problem of simultaneity than that proposed in earlier works such as the *Woman with a Mandolin* and the *Portrait of Josette* (pages 69 and 71). But Gris had at least approached this solution in the *Harlequin with a Guitar* of 1917 (page 86).

THE FINAL YEARS: 1920–27

In February, 1920, Kahnweiler returned to Paris to reopen his gallery. Of the paintings Gris had executed in his absence, he has said: "I had left behind a young painter whose works I liked. I had returned to find a master."[55] In this instance Kahnweiler was speaking of the pictures Gris had done during the war years and in 1919. But there can be no doubt, considering the many other things he has said and written, that Kahnweiler believes the years between 1920 and the painter's death in 1927 to have been one of the most creative periods of Gris' short life. In his monograph, Kahnweiler has put the matter bluntly: "The period that followed [1920] was one of the most fruitful and beautiful in the whole of Juan Gris' work. Indeed, many of those who admire his pictures consider the years 1916 to 1919 as the peak of his achievement. Certainly the works of this

[54] Barr, Alfred H. Jr., *Picasso*, op. cit., p. 77
[55] Kahnweiler, bibl. 37, p. 16

opposite: *House in a Landscape*. 1918. Oil on canvas, 36 × 25½".
Rijksmuseum Kröller-Müller, Otterlo

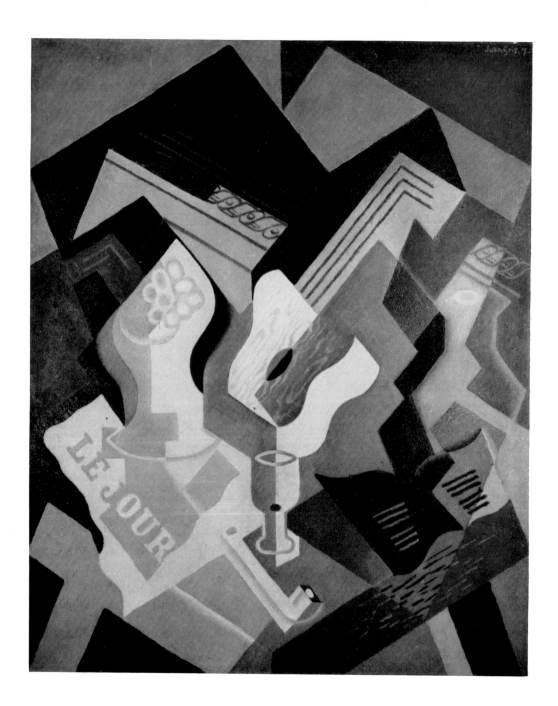

94

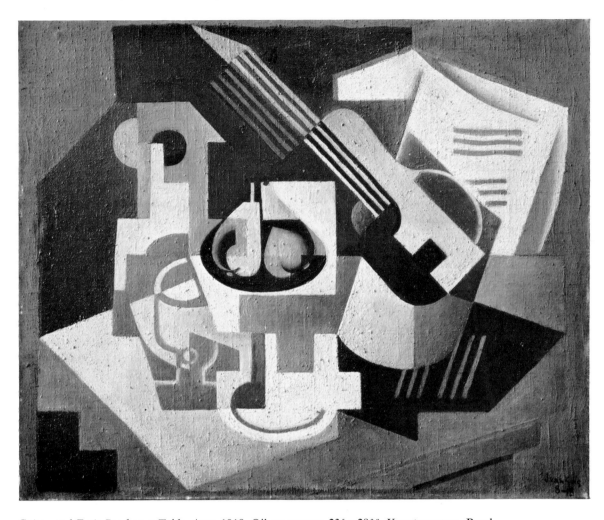

Guitar and Fruit Bowl on a Table. Aug. 1918. Oil on canvas, $23\frac{5}{8} \times 28\frac{3}{4}''$. Kunstmuseum, Basel

opposite: *Guitar and Fruit Bowl.* July 1919. Oil on canvas, $28\frac{3}{4} \times 23\frac{3}{4}''$
Collection Niels Onstad, New York

time have an austere grandeur and manly vigor . . . And yet I do not think that one can be said to have fully understood Gris' art unless one recognizes the progress which he continued to make after 1920."[56]

It is the present writer's painful duty of conscience to disagree with the distinguished man of whom Gertrude Stein, as noted, declared: "No one can say that Henry Kahnweiler can be left out of him [Gris]." It is unquestionably true that Gris completed some excellent works during the final seven years of his life, among them, it is to be hoped, the late paintings herewith reproduced. Nevertheless, one questions whether Gris was ever again after 1920 as consistently inspired an artist as he had been before, perhaps due in part to chronic illness, in part to his absorption for a time in stage design.[57] This absorption has proved debilitating to numerous artists of our century, who despite themselves have sometimes confused the emotional and intellectual requirements of the theater with those of the painter's solitary studio. In Kahnweiler's opinion the reservations many of us feel about some of Gris's late works can be ascribed to "an old misunderstanding of cubism."[58] The theory is rather hard to credit in that many of Gris' most fervent admirers have been devoted to the cubist movement and a few of them have made it the subject of prolonged research. It is only fair to add, however, that Kahnweiler's opinion about Gris' final works was shared by the late Curt Valentin, who did so much to further the artist's fame in this country and was obviously one of the most sensitive and dedicated dealers of our time. It is shared today by Douglas Cooper, whose Gris collection is one of the finest in existence and who has long been engaged in compiling a *catalogue raisonné* of the painter's works. While paying full tribute to Gris' earlier masterworks, Cooper concludes: "It is only in 1920 that Gris at last seems in full possession of his resources."[59]

[56] Kahnweiler, bibl. 37, p. 91
[57] Vide *Gris Letters*, bibl. 8, pp. 159–161. On December 15, 1923, during the period when he was at work on Diaghilev's ballet sets for *Les Tentations de la Bergère* and *La Colombe*, Gris wrote to M. and Mme André Beaudin as follows: "My life has been poisoned by the theatre. . . ." On the same day, in a letter to Maurice Raynal, he wrote: "All the time I am worried about the décors and that prevents me from working at my own painting. It is really difficult to do two things at once." And on December 9 he had written to Kahnweiler to say that he was in the midst of a painting crisis: "I really feel that I am going through a bad period. I don't feel confident in any medium and I'm utterly devoid of self-assurance in my work."
[58] Kahnweiler, bibl. 37, p. 91
[59] Cooper, bibl. 20, p. [9]

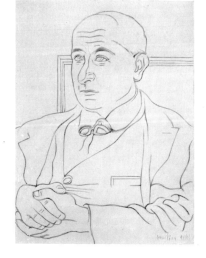

Portrait of Max Jacob. 1919. Pencil, $14\frac{1}{4} \times 10\frac{1}{2}''$. Private collection, New Canaan, Conn.

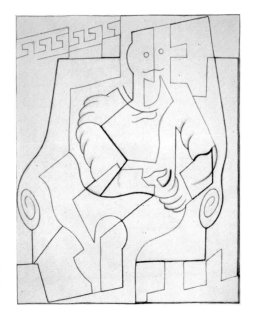

Study for *Seated Harlequin*. Jan. 1920. Pencil, $13\frac{1}{2} \times 10\frac{5}{8}''$. Fine Arts Associates, New York

Early in 1920 Gris exhibited more frequently than he ever had before, in January at the Section d'Or in Paris, later at the Salon des Indépendants and in a cubist show at the Galerie Moos in Geneva. His entries in the Salon had a decisive success, and were vigorously supported by Picasso and Gertrude Stein, though not by Braque, whom Gris accuses in a letter of January 31st of "running me down as much as he can."[60] He seems at this point and more especially later in the year to have concentrated on heightening the lyric impact of his pictures. As early as 1915 he had been worried about his art's lack of sensuality – "I can't find room in my pictures for that sensitive and sensuous side which I feel should always be there."[61] – and now, in 1920, he deliberately sought poetic effects. But in May he became ill with pleurisy and was taken to the Tenon Hospital. It was August before he was released and could go to Beaulieu; it was September before he could summon the strength to paint again. In the autumn he went back to Paris briefly and saw the new gallery of Kahnweiler, who had again become his dealer after a quarrel between Gris and Léonce Rosenberg. (Rosenberg, however, retained the right of first refusal on canvases of certain sizes.) The Paris climate proved too harsh for his weakened chest, and in November he and Josette went to Bandol, on the Mediterranean near Toulon.

[60] *Gris Letters*, bibl. 8, p. 76
[61] *Gris Letters*, bibl. 8, p. 33

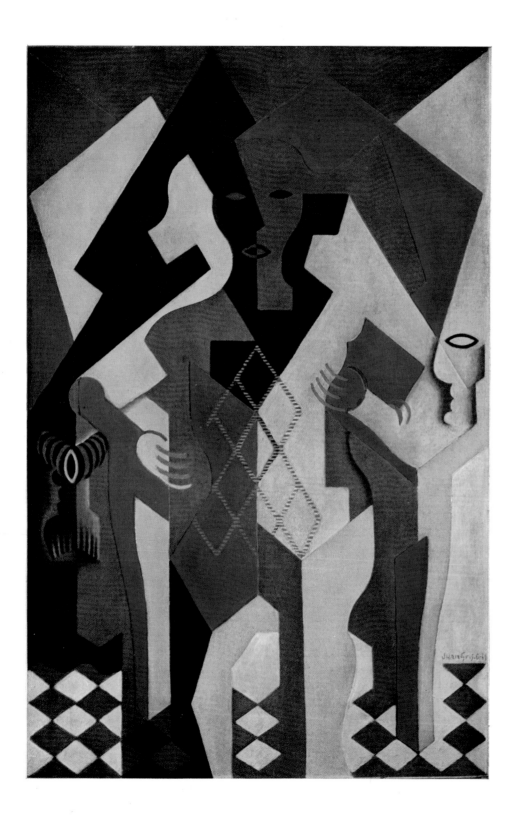

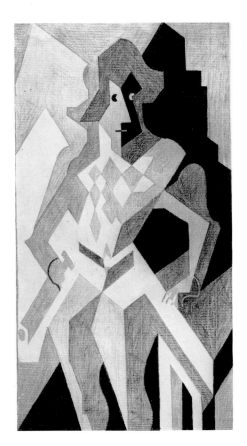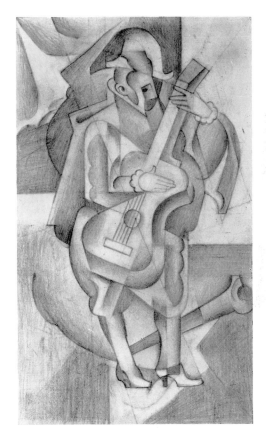

left: *The Harlequin*. 1918 (?). Charcoal, 19 × 12⅜″. Collection Mr. and Mrs. Richard S. Davis, Wayzata, Minn. right: *Man with Guitar*. 1918. Pencil, 14 × 5¼″. Collection Mr. and Mrs. Harry L. Winston, Birmingham, Mich.

opposite: *Harlequin*. June 1919. Oil on canvas, 39⅝ × 25¾″.
Collection Mr. and Mrs. Morton G. Neumann, Chicago

left: *Marcelle the Blonde*. March 1921. Lithograph, printed in brick red, $11\frac{5}{8} \times 8\frac{7}{8}''$. The Museum of Modern Art, New York, gift of Mrs. John D. Rockefeller, Jr. right: *Marcelle the Brunette*. March 1921. Lithograph, printed in green, $11\frac{3}{4} \times 9''$. The Museum of Modern Art, New York, gift of Mrs. John D. Rockefeller, Jr.

In January, 1921, Gris began his series of "open window" paintings, and in March worked on four lithographic portraits, among them *Marcelle the Blonde* and *Marcelle the Brunette* (above). In April he was summoned to Monte Carlo by Diaghilev to do the décor for a suite of Andalusian dances and songs called *Cuadro Flamenco*. From his letters it is obvious that he was reluctant to accept the commission (which eventually fell through) and miserable in Monte Carlo: "I can't stand this sort of Universal Exhibition landscape, where one sees nothing but bad architecture, bloated people with idiotic expressions or intriguers."[62]

Why, then, did he accept Diaghilev's proposal? His own words give the answer: "if I refuse I shall be flying in the face of fortune, since a ballet can help me to make my name known and bring me admirers."[63] There was a special

[62] *Gris Letters*, bibl. 8, p. 111
[63] *Gris Letters*, bibl. 8, p. 109

Design for ballet set, *Les Tentations de la Bergère*. 1923.
Watercolor, $9\frac{1}{2} \times 12\frac{1}{4}''$. Wadsworth Atheneum, Hartford,
Conn. (Not in exhibition)

reason at this time why Gris was eager to be better known. He had been aware
since January that the sequestered stock of the pre-war Galerie Kahnweiler was
to be sold at auction. This stock included a number of his own pictures, of course,
and he may well have feared that their auction prices would be disastrously low.
His fears, if any, were well grounded. At the Kahnweiler sale at the Hotel
Drouot on June 13th and 14th, 1921, the Gris prices were far lower than those
paid for pictures by Friesz, Derain, van Dongen, Vlaminck, Léger and, natur-
ally, Picasso. Moreover, at the Uhde sale in May of the same year one of his
paintings brought the miserable price of slightly over 528 francs, much less than
was paid for a painting by the minor cubist, Herbin.

As briefly noted the Diaghilev commission for *Cuadro Flamenco* was canceled,
and late in April Gris arrived back in Bandol, exhausted by his experience and em-
bittered by the fact that Picasso, who took over the commission, had apparently
spoken against him: "It was decided in Madrid that I should do this décor and
the dancers knew about it. But when they got to Paris it had to be done in a great
hurry, and Picasso got away with it by producing a set of designs already made,
saying that I would never be able to do it in so short a time. He seems also to
have rattled the skeleton of cubism and dwelt on the difficulties of executing any
conception of mine."[64]

In 1922 and 1923 Gris finally designed for Diaghilev the décor for the ballet,
Les Tentations de la Bergère (above), the settings for *Fête Merveilleuse* at

[64] *Gris Letters*, bibl. 8, p. 112

Boris. 1921. Lithograph, printed in black, $10\frac{7}{8} \times 8\frac{3}{8}''$.
The Museum of Modern Art, New York, Purchase 1948

Versailles, and the décor for two additional ballets, *La Colombe* and *L'Education Manquée*. But if his resentment toward Picasso was probably justified in the case of the ill-fated *Cuadro Flamenco*, it must be said that the latter was not entirely wrong in feeling that his painstaking colleague's talents were not really appropriate for stage design. In part this was because Gris remained at heart so pure a cubist and, as Kahnweiler has remarked: "Cubism did not carry into the theatre the revolution which it brought about in the plastic arts."[65] The movement's influence on stage design was nevertheless considerable, and in this connection a letter from Lincoln Kirstein to the present writer is of interest: "Gris' talent was anti-theatrical, but his style has been commercialized, and I would bet half the opera houses of the world from Buenos Aires to Brussels (particularly the provinces) have done modernoid, modernique or modernesque-type cubist works based on Gris' inventions, much more than on anybody else, since he was so defined and clear. Gris was an incident; only his easel paintings throw by indirection a certain interest on his theatrical designs."[66]

Since the writer has never seen an actual stage production designed by Gris, no further mention of the subject will be made here. But the artist's relentless faith in painting is confirmed by the fact that the month after his return to

[65] Kahnweiler, bibl. 37, p. 115
[66] Kirstein, Lincoln [In letter to the writer], August 22, 1957

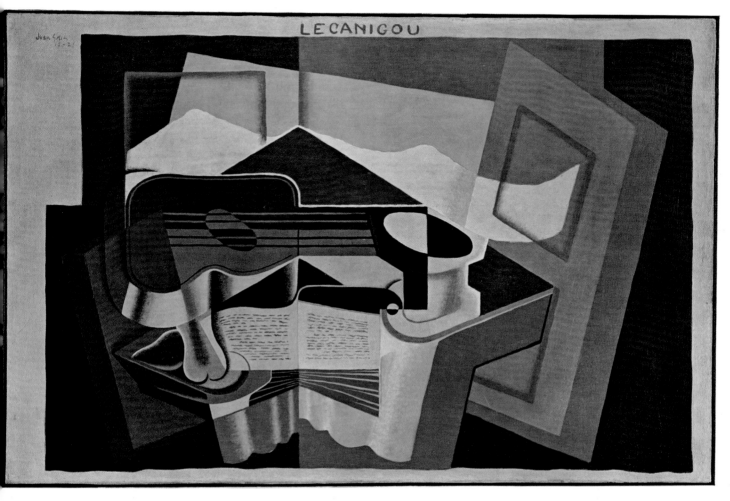

Le Canigou. Dec. 1921. Oil on canvas, 25¾ × 39⅝″. Room of Contemporary Art Collection, Albright Art Gallery, Buffalo. (Exhibited in New York and Minneapolis)

Bandol from Monte Carlo in April, 1921, he completed the ambitious *Before the Bay* (page 103), in which he returned to the problem of combining interior with exterior scenes, a problem which had engaged him in Paris when he painted the *Place Ravignan* in 1915. Now, however, he came far nearer to realism in the traditional sense, as in the painting of the sailboat and the mountain beyond. And he had gained so much compositional assurance that his letter to Amédée Ozenfant of late March is worth quoting: "Today, *mon cher*, you can believe me when I say that not only do I know the attributes of every size and shape of canvas – F, P or M[67] – but that I can produce to order a composition to suit any given area. And while I'm on this point, I wonder whether you have noticed that the majority of my latest things done here are on M shapes? Well, this has nothing to do with the 'golden section.'"[68] Since the M shape of French canvases is the most flexible in the relationship of one dimension to the other, one senses here a quiet reproach to the Purists, Ozenfant and Jeanneret (Le Corbusier), who were trying in Gris' opinion to reduce painting to a mechanical, even utilitarian formula. The reproach is more explicit in a letter to Kahnweiler about Purism, on whose adherents Gris' influence, despite himself, was strong: "It would be as grotesque to commission a craftsman to make one of the painted objects in a picture of mine as to turn a Poussin or a Chardin into sculpture . . ."[69]

Late in June Gris and his wife returned to Paris, where the painter executed a series of portrait drawings of members of the Kahnweiler family. His interest in doing this sort of drawing may have been revived by several commissions of the kind which he had received during his otherwise abortive stay in Monte Carlo in the spring of 1921.

In October the Gris family went back to Céret, and there in December the painter completed one of the finest of his pictures of the 1920s, *Le Canigou* (opposite), its title derived from the name of the mountain peak in the Eastern Pyrenees near Céret. The artist himself was pleased with this picture, as well he might have been – "I am really enthusiastic about a picture I am beginning of the white peak of the Canigou covered with snow."[70] One doubts that a mountain in winter has ever been represented in more abstract terms (consider, by contrast, what a Romantic like Caspar David Friedrich did with such subjects)

[67] The French number each size of canvas from 1 to 120 by three different shapes: F (for figure pieces); P (for landscapes); and M (for marine subjects)
[68] *Gris Letters*, bibl. 8, pp. 105, 106
[69] *Gris Letters*, bibl. 8, p. 107
[70] *Gris Letters*, bibl. 8, p. 134

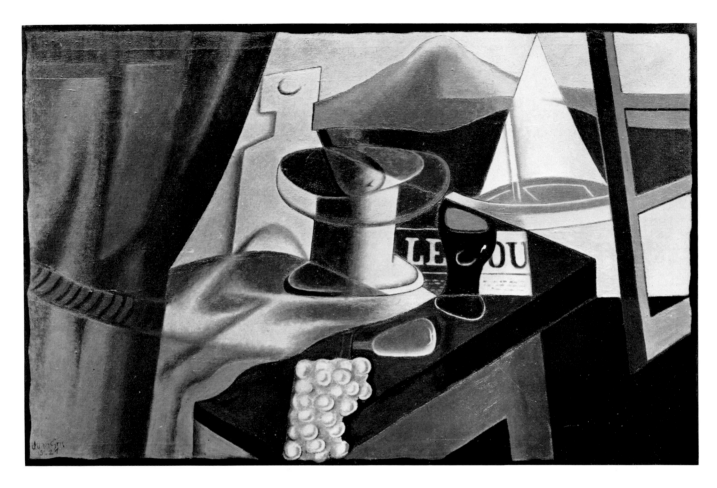

Before the Bay. May 1921. Oil on canvas, 24 × 37⅜″. Collection Mr. and Mrs. Gustav Kahnweiler, Gerrards Cross, Buckinghamshire, England

and yet sometimes in Gris' art there is an allusive sense of climate. Though the white band of snow-covered peaks is only a background detail, its reflections are felt in the icy lighting of the still life in the foreground interior. More perhaps than any of his colleagues in cubism, Gris was sensitive to the physical modulations of the environment in which he worked. His art changed as he moved from place to place, and it is no exaggeration to say that he would not have done in Paris in exactly the same way the pictures he painted in Céret, Beaulieu or Bandol.

In Paris Gris had resumed figure painting, and in October had completed *The Pierrot* now in the collection of John L. Sweeney, Boston. At Céret, in January, he worked to finish the *Pierrot with Guitar* (opposite), and during the same year painted *Two Pierrots* (page 108), in which circular forms are used in eloquent profusion – for the eyes of the figures, the shapes of their heads, the buttons on their coats. If at this time Gris complained of being bored and irked by the provincialism of his neighbors – "We wanted to dance to the gramophone but their wives didn't know the latest dances"[71] – there is no sign of ennui in the courageous *Two Pierrots* nor in the *Pierrot with Guitar* to which Gris referred in a letter to Kahnweiler: "I have a picture of a seated pierrot which is quite far advanced and looks rather good. I think it's much better than the one I did in Paris."[72] He seems to have felt a renewed confidence at this moment, and in the same letter wrote: "Being isolated here makes me feel less dissatisfied with my work. I wonder whether it's the result of demoralization or of a more complete mastery of my art. In any case I no longer feel so disgusted with my own painting as I used to."[73]

But in the early spring Gris' chronic depression of mind returned, and he struggled to complete a series of small paintings as a respite from the winter's ambitious figure pieces which parallel to some degree the hardy, cylindrical inventions of Léger. In April Gris and Josette moved back to Paris. Almost at once they left their old quarters on the rue Ravignan and moved into a suburban flat Kahnweiler had found for them near his own at Boulogne-sur-Seine. Josette was elated by the prospect of the change. She nevertheless added a touching

[71] *Gris Letters*, bibl. 8, p. 138
[72] *Gris Letters*, bibl. 8, p. 140
[73] *Gris Letters*, bibl. 8, p. 141

opposite: *Pierrot with Guitar*. Jan. 1922. Oil on canvas, 45½ × 28½". Collection Haakon Onstad, Munkedal, Sweden

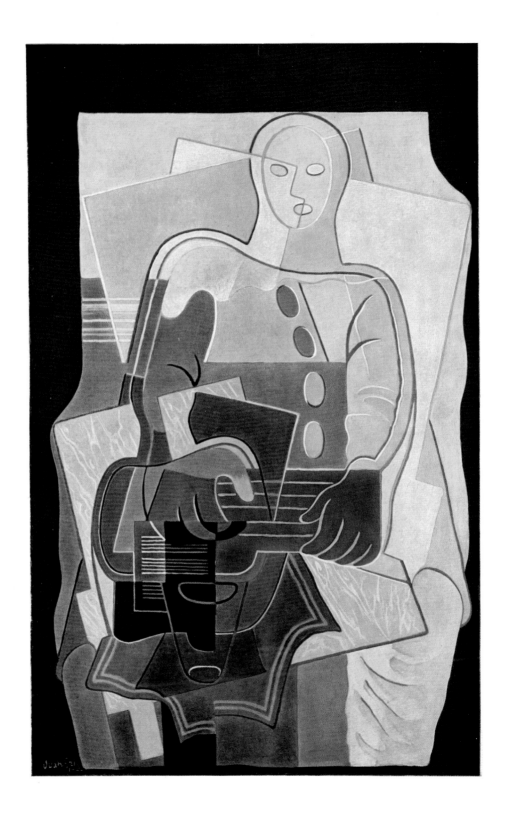

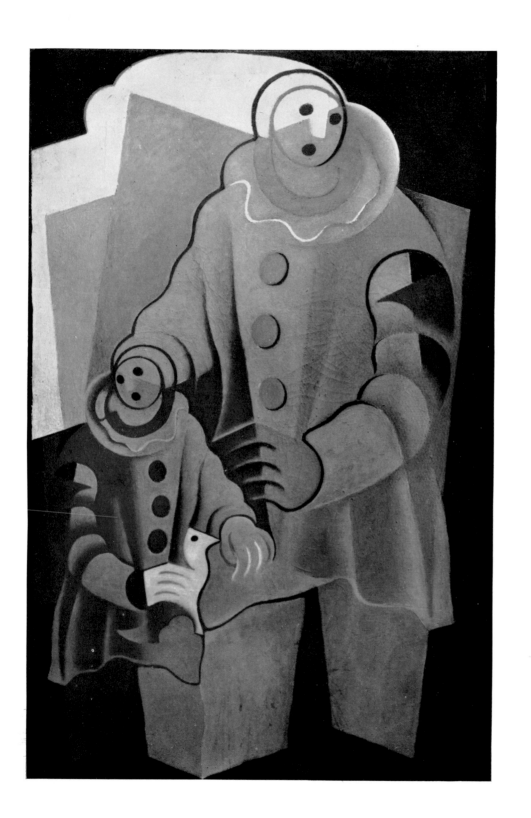

Two Pierrots. 1922. Pencil, $9 \times 5\frac{5}{8}''$.
Collection Mr. and Mrs. Matthew
H. Futter, New York

commentary on the prospect in a letter to Kahnweiler: "I don't know whether, as far as his work is concerned, Jean will be better off in the new flat, but I shall certainly be glad not to be with him while he is working. He heaves such heavy sighs, and that depresses me."[74]

The spring, summer and fall of 1922 were trying for both Gris and his wife, she having suffered from an abscess of the mouth in August and he having undergone an operation for an anal fistula in October. And even though Gris' operation was successful, he remained lethargic and weak. In a letter to Gertrude Stein he confessed: "I want to begin working but I haven't the strength. I must turn back into being a painter because my state of mind is still that of an invalid."[75]

During this bitter period of his life (1922–23), Gris may have been heartened or at least distracted by finally receiving the four definite commissions from Diaghilev noted on pages 101–102; three of his ballets had their *premières* in Monte Carlo in January, 1924. He may have been cheered, too, by his exhibition at Kahnweiler's Galerie Simon in March, 1923, though he warned beforehand: "I'm not expecting it to have a great success because there are not many people who like my painting."[76] And Monte Carlo, where he went in the spring of 1923 to supervise the execution of his ballet sets, depressed him as much as ever – "Monte Carlo is as boring as a sanatorium."[77]

Considering such factors as ill health, lack of worldly success and an uneasy if sometimes proud response to the challenge of stage design, it is all the more commendable that Gris was able to produce in his final years a number of distinguished works. Among them are: the *Seated Harlequin* of 1923 (page 111), as impudent as pistachio, as compelling as a gong; *The Scissors* (page 112); the poetic *Drummer* (page 113); the *Guitar with Sheet of Music* (page 114); like the last two named done in 1926; and the *Book and Fruit Bowl* (page 115), painted the year Gris died of uremia at forty.

These are, of course, by no means the only major pictures Gris completed during the mid-1920s. Nevertheless, the question remains as to why a number of the artist's late works seem calculated and wan and sometimes, though rarely, sentimental. Apart from the factors mentioned above, it is reasonable to assume

[74] Kahnweiler, bibl. 37, p. 23
[75] *Gris Letters*, bibl. 8, p. 149
[76] *Gris Letters*, bibl. 8, p. 151
[77] *Gris Letters*, bibl. 8, p. 155

opposite: *Two Pierrots*. 1922. Oil on canvas, $39\frac{1}{2} \times 25\frac{1}{2}''$.
Collection Mr. and Mrs. Harold Hecht, Beverly Hills, Calif.

that Gris missed the nourishment which the cubist movement had provided during his earlier career. Despite his occasional quarrels or misunderstandings with Picasso and Braque, there can be no doubt that he revered the talents of both men. By 1922 cubism and its two great founders had begun to leave Gris in the lurch, so to speak. Before painting the climactic *Three Musicians* in 1921, Picasso had at times turned to neo-classicism, later to the sumptuous and more naturalistic still lifes of 1924–25 and, finally, to the *Three Dancers* of the latter year, a picture whose convulsive spirit allies it to surrealism and to that psychological chaos which Gris had abhorred in the art of the Dadaists some years before. Braque, also, by 1924 had become more deliberately sensuous in the decorative sense, and was producing those large, soft figure pieces which he called *The Canephorae* (basket carriers) to emphasize their relationship to traditional classicism. Gris, on the contrary, tried to remain more faithful to the cubist premise. It may be an exaggeration to say that he suffered from his own fidelity and singlemindedness, and certainly his lifelong dedication earned him Lipchitz' complimentary description – "*the* cubist."[78] Yet cubism as a movement of profoundly revolutionary and original character could not go on unchanged forever. Gris, one assumes, had no strength left for counter-revolution.

In support of this theory it is interesting to note that in 1924 and 1925 Gris spent much of his time and energy in lecturing and in writing down his conception of what painting should be and why. As early as 1921 he had made a pertinent statement about his basic philosophy as an artist: "I consider that the architectural element in painting is mathematics, the abstract side; I want to humanize it. Cézanne turns a bottle into a cylinder, but I begin with a cylinder and create an individual of a special type: I make a bottle – a particular bottle – out of a cylinder."[79] In 1924, lecturing at the Sorbonne, he made clearer his basic faith in the possibility of transfiguring reality without hopelessly compromising its identity: "One of my friends, a painter [Georges Braque], has written: 'Nails are not made from nails but from iron.' I apologize for contradicting him, but I believe exactly the opposite. Nails are made from nails, for if the idea of the possibility of a nail did not exist in advance, there would be a serious risk that the material might be used to make a hammer or a curling tong."[80]

[78] Lipchitz, Jacques. See footnote 8, p. 10
[79] Gris, Juan, bibl. 4, p. 534
[80] Kahnweiler, bibl. 37, p. 139. The lecture was first published in the *Transatlantic Review*, June, July, 1924 (bibl. 1)

110

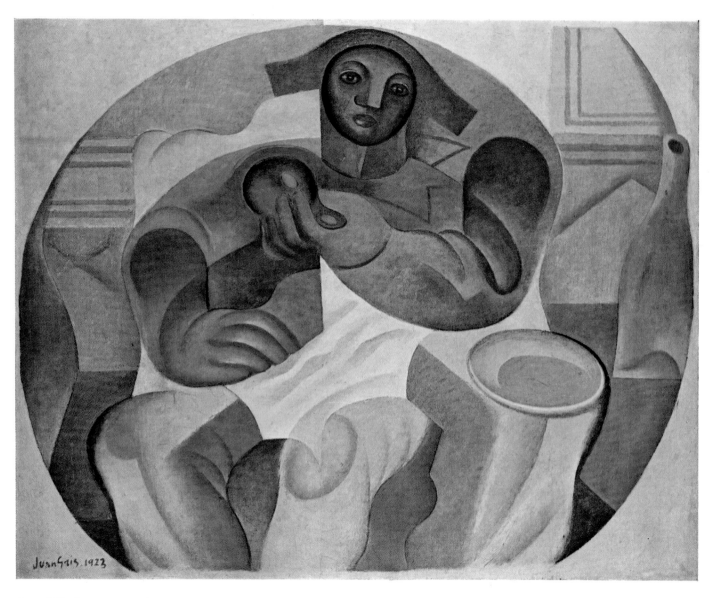

Seated Harlequin. 1923. Oil on canvas, $28\frac{3}{4} \times 36\frac{1}{8}''$. Collection Dr. Herschel Carey Walker, New York

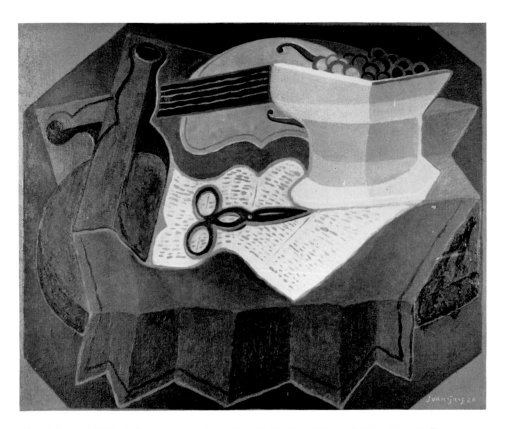

The Scissors. 1926. Oil on canvas, 19½ × 24″. Collection Mr. and Mrs. Sam Jaffe, Beverly Hills, Calif. (Exhibited in New York and Los Angeles)

The statement epitomizes Gris' eager, even frenzied longing to create in terms of pure painting, as opposed to stylistic adventure, a new commentary on the tangible world's familiar objects. He did not wish to make art out of parody, as Picasso has often done; he would have rejected the classical allusions which interested Braque in painting *The Canephorae*. One of the most deeply embedded qualities of his mind was thoughtfulness, and his seriousness was unwavering. His veneration for the art of the past is a case in point. He haunted museums constantly, but chiefly to penetrate the secrets of his craft rather than to refurbish his iconographical and stylistic approach. We know, as already

opposite: *Drummer*. 1926. Oil on canvas, 39¾ × 32″.
Collection Mr. and Mrs. William Bernoudy, St. Louis

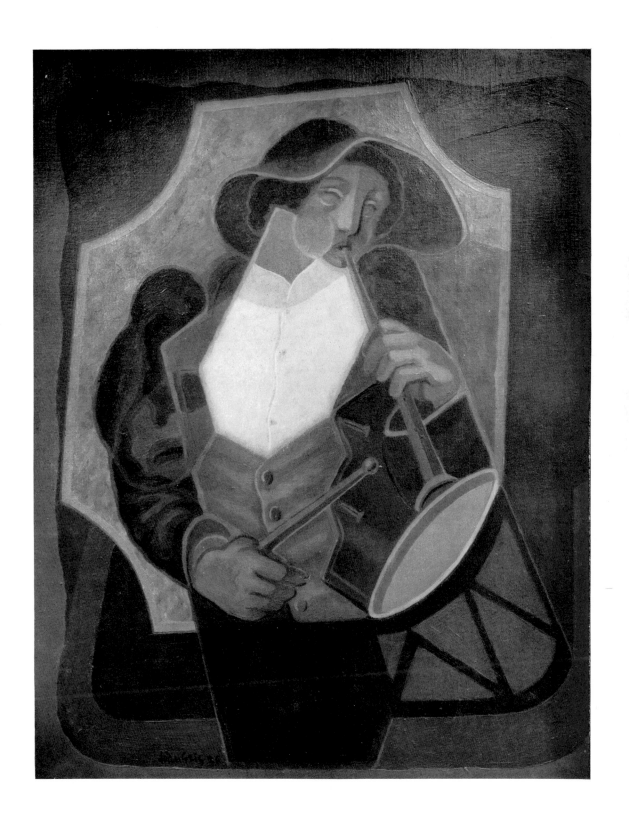

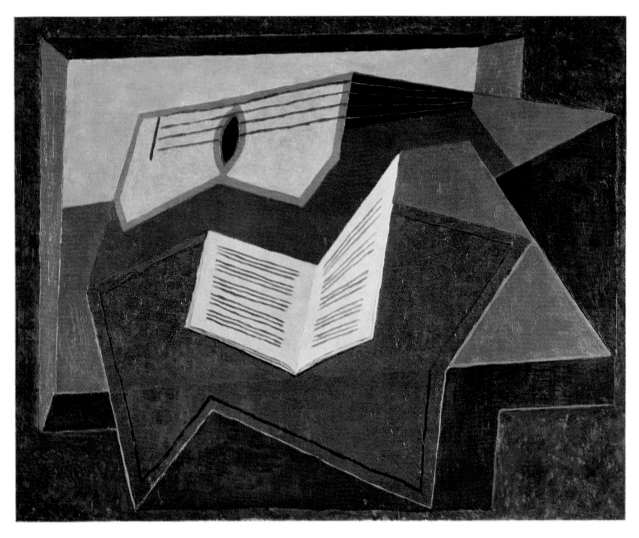

Guitar with Sheet of Music. 1926. Oil on canvas, 25⅝ × 31⅞″. Collection Mr. and Mrs. Daniel Saidenberg, New York

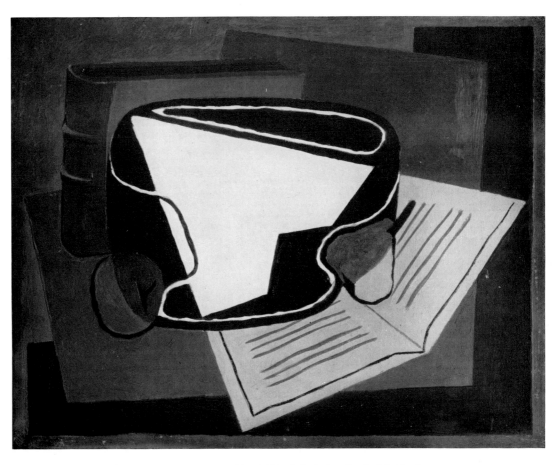

Book and Fruit Bowl. 1927. Oil on canvas, 13 × 16⅛″. Galerie Louise Leiris, Paris

mentioned, that during his later career he studied the work of the Fontainebleau Mannerists. No sign of their nervous elegance appears in his art,[81] whereas Picasso on several occasions, notably in 1904–06 and 1918–25, had converted what Barr has called the "fat and lean" exaggerations of the sixteenth-century Italian Mannerists into a vehicle for both wit and monumentality.[82] To the very end Gris remained faithful to, and perhaps at times the prisoner of, what Kahnweiler has called his "rapturous lucidity."[83]

"Sick men," Gris once remarked, "paint stiffly."[84] It is to his overwhelming credit that he himself struggled valiantly against this rigidity from the time his health began to fail seriously in the late summer of 1925 until his death on May 11th, 1927. He continued to produce a considerable body of work, paintings, watercolors, gouaches, drawings, prints and book illustrations. The quantity of his work is the more remarkable in that his health demanded that he move about in hope of some respite from his terrible bouts of asthma: to Toulon, back to Boulogne, to Hyères and to Puget-Theniers, where his illness was diagnosed as uremia. On January 24, 1927, he returned in desperation to Paris. He recovered somewhat in February and began to work again. But in March he weakened, and his brave struggle and frightful suffering were nearly over.

On May 13 Gris was buried at Boulogne. Kahnweiler writes: "There were neither speeches nor a religious ceremony, but in the procession which filed down the Avenue de la Reine to the old cemetery of Boulogne were all those who had known Gris – painters, sculptors, poets and musicians. The chief mourners were his son Georges, Lipchitz, Picasso, Raynal and myself."[85]

[81] The artist himself would not have agreed. On January 26, 1926 he informed Kahnweiler that he was at work on two figure paintings which "have a Pompeian look, but more the Pompeian of David than of Poussin." (*Gris Letters*, p. 179). But on February 6 of the same year he writes his dealer of one of these two works as follows: "Now that she is finished the woman with the drapery is more like something from Fontainebleau than from Pompeii." (*Gris Letters*, p. 181). The painting referred to is *Woman with Drapery*, 28¾ × 23⅝ in., dated 1926, Galerie Chichio Haller, Zurich.

[82] Barr, Alfred H. Jr., *Picasso*, op. cit., p. 106

[83] Kahnweiler, bibl. 37, p. 134

[84] Kahnweiler, bibl. 37, p. 107

[85] Kahnweiler, bibl. 37, p. 36

CHRONOLOGY

1887 March 23: José Victoriano Gonzalez (later known as Juan Gris) born in Madrid.

1902 Gris enters *Escuela de Artes y Manufacturas* in Madrid. Begins to contribute drawings to *Blanco y Negro* and *Madrid Comico*.

1904 Leaves the *Escuela* to devote himself to art. Studies painting with José Maria Carbonero for a period of less than two years. Works in the style of *Art Nouveau*, under the influence of magazines *Jugend* and *Simplicissimus*.

1906 Illustrations for José Santos Chocano's *Alma America*. Arrival in Paris. Takes up residence at *Le Bateau Lavoir*, 13 rue Ravignan, where Picasso lives. Meets Guillaume Apollinaire, Max Jacob, André Salmon and others. Contributes drawings to *L'Assiette au Beurre*, *Le Charivari* and *Le Cri de Paris* (later to *Le Témoin*).

1908 Gris meets Kahnweiler.

1909 April 9: Birth of Gris' son, Georges Gonzalez.

1910 Continues to contribute drawings and caricatures to *L'Assiette au Beurre*, working in the manner of *Art Nouveau*. At the same time paints more intensively in watercolor and colored crayon, under the modified influence of cubism. (See *Still Life with Bottle*, page 15.)

1911 First ventures in analytical cubism. (See *Still Life*, p. 16.) Sells first paintings to Clovis Sagot.

1912 Picasso and Braque begin *papiers collés*. Gris paints Picasso's portrait (see page 18). March: Exhibits at the Salon des Indépendants. June: Represented at the Cubist exhibition of the *Société de Peinture Moderne* in Rouen. Summer: Invents "grid" system of composition which is rapidly adopted by Gleizes and Metzinger (see *The Watch*, page 23). October: Exhibits at Section d'Or. Kahnweiler makes contract to buy all his work. Gris starts to work with areas of pure and intense color (see *Guitar and Flowers*, page 19). Hermann Rupf of Bern buys his first Gris painting. Josette joins Gris at 13 rue Ravignan. First use of *papiers collés* elements. (See *The Watch*.)

1913 August to November: Gris and Josette stay at Céret. Gris often sees Manolo who is also there. Autumn: Paints *Smoker* (page 30), *Violin and Guitar*

(page 29), *Still Life with Pears* (page 32), and *Violin and Checkerboard* (page 33). Gertrude Stein and Léonce Rosenberg buy their first Gris paintings. November: Return to Paris.

1914 Paintings made almost exclusively with *papiers collés* (see pages 36–47). June: Gris and Josette leave for Collioure. Friendship with Matisse, Marquet. October: Return to Paris. Acute financial difficulties. Through intervention of Matisse, temporary arrangement made with Gertrude Stein and Michael Brenner, American sculptor and dealer, who, between them, promise to send Gris 125 fr. per month in exchange for paintings. Kahnweiler moves to Bern to escape persecution as enemy alien.

1915 Spring: Léonce Rosenberg tries to buy pictures directly from Gris. Gris illustrates Reverdy's *Poèmes en Prose* (bibl. 9). June: First "open window" painting, combining interior and exterior views (see *Still Life before an Open Window: Place Ravignan*, page 53). Sees Metzinger often. December: Suspends contract with Kahnweiler.

1916 Gris' "architectural" period begins. Léonce Rosenberg begins to buy all of Gris' production of pictures done after the spring of 1915. September: The Gris' go to Beaulieu. *Portrait of Josette, Woman with a Mandolin* (pp. 71, 69). November: They return to Paris. Pierre Reverdy and Max Jacob are frequent visitors.

1917 Friendship with Lipchitz. Winter: *Harlequin* in polychrome plaster (page 72). February: *Still Life*, Minneapolis Institute of Arts (p. 74). March: *The Chessboard* (page 75). July: *Landscape* (page 82). August: *The Sideboard* (page 79). November: Signs contract with Léonce Rosenberg for three years, with the dealer given the option of renewal for an additional three years. December: *Harlequin with Guitar* (page 86).

1918 April: Gris and Josette return to Beaulieu. Close contact with Lipchitz, who is also there.

Drawing after Cézanne *Self Portrait*.
1916. Pencil, 14½ × 11″. Collection Mr.
and Mrs. Richard S. Davis, Wayzata,
Minn.

February: *Still Life with Fruit Bowl* (page 88), *Violin and Glass* (page 89).
March: *Newspaper and Fruit Bowl* (page 91).
November: Return to Paris.

1919 April: Exhibition of fifty pictures dated 1916, '17, '18, at Galerie de l'Effort Moderne (Léonce Rosenberg), Paris. Illustrates Reverdy's *La Guitare Endormie* (bibl. 9a).
May: Begins first series of harlequins.
June: *Harlequin* (page 98).
July: *Guitar and Fruit Bowl* (page 94).
August: Kahnweiler resumes relations with Gris from Switzerland, claims pictures due him from 1914–15 under old contract; makes overtures for new contract.
Alfred Flechtheim, German dealer, begins to buy Gris pictures.

1920 January: Gris exhibits at the Section d'Or, Paris.
February: Exhibits at the Salon des Indépendants. Kahnweiler returns to Paris.
May: Gris revises contract with Léonce Rosenberg, allotting Kahnweiler a portion of his current output. First illness, which develops into pleurisy. Enters Tenon hospital.
August: Leaves hospital for Beaulieu with Josette.

September: Begins to paint once more. Kahnweiler opens the Galerie Simon, rue d'Astorg, Paris.
End of October: Returns to Paris.
November 30: Gris and Josette go to Bandol.
December: At work on lithographs for Max Jacob's *Ne Coupez pas Mademoiselle*, published the following year by Galerie Simon (bibl. 10).
Publication of Maurice Raynal's *Juan Gris* (bibl. 46).

1921 Resumes series of "open windows" (See *Le Canigou*, page 103; *Before the Bay*, page 105).
February: Publishes statements on painting in *L'Esprit Nouveau* (bibl. 4).
April: Goes to Monte Carlo to work on décor for *Cuadro Flamenco*, at Diaghilev's invitation. Project falls through when Picasso receives commission; Gris does three portrait drawings for souvenir program.
June 22: Gris goes to Le Cannet and subsequently returns to Paris. First auction of sequestered stock of pre-war Kahnweiler Gallery; Gris prices far lower than those paid for Picasso, Léger, Derain, Vlaminck, van Dongen. Portrait drawings of the Kahnweiler family.
October: Second series of Pierrots and Harlequins is begun in Paris, to be continued in Céret in January. Gris and Josette go to Céret. Manolo is there.

1922 January: *Pierrot with Guitar* (page 107).
April: Gris and Josette return to Paris and move to 8 rue de la Mairie, Boulogne-sur-Seine.
October 3: Operation for anal fistula; eight-day convalescence in hospital.
November: Diaghilev commissions sets and costumes for the ballet *Les Tentations de la Bergère*.

1923 Exhibition at Galerie Simon, Paris.
June: Executes sets for *Fête Merveilleuse*, organized by Diaghilev at Versailles.
Summer: Diaghilev commissions the décor for the ballet *La Colombe*.
"Notes on My Painting" published in *Der Querschnitt* (bibl. 6).
October: Gris and Josette leave for Monte Carlo where he supervises executions of his décors.
December: Diaghilev commissions the décor for *L'Education Manquée* of Chabrier.
Gris writes to Kahnweiler that his painting is going through a "bad period."

1924 January: Monte Carlo, first performances of *Les Tentations de la Bergère*, *La Colombe* and *L'Education Manquée*.

February: Gris and Josette return to Boulogne.
May: Gris delivers a lecture at the Sorbonne, "On the Possibilities of Painting" (bibl. 1).

1925 January: Publication in the *Bulletin de la Vie Artistique* of Gris text, "*Chez les Cubistes*" (bibl. 6).
April: Exhibition at Galerie Flechtheim, Dusseldorf.
August: Gris' health deteriorates.
At work on etchings for Tristan Tzara's *Mouchoir de Nuages* (bibl. 11).
December: Gris and Josette go to Toulon; Gris is at work on lithographs for *A Book Concluding With As A Wife Has A Cow A Love Story*, by Gertrude Stein (bibl. 13).

1926 February: Gris' health worsens; ill with bronchitis.
At work on lithographs for *Dénise*, by Raymond Radiguet (bibl. 12).
March: Works on watercolors and gouaches.
April: Gris and Josette return to Boulogne.
November: Gris and Josette at Hyères.
December: Gris suffers acute and prolonged attacks of asthma; health declines, and he is unable to work.

1927 January 22: Gris goes to Puget-Théniers where his illness is diagnosed as uremia.
January 24: Gris and Josette return to Paris.
May 11: Juan Gris dies at the age of 40.
May 13: Burial of Juan Gris at Boulogne-sur-Seine.

NOTE: The chronology above by Sam Hunter, of the Department of Painting and Sculpture, is essentially a condensation of Douglas Cooper's chronological table in *Juan Gris, His Life and Work*. It has been prepared with the latter's kind permission. A number of Mr. Cooper's later revisions and emendations of his original chronology are also included. Wherever possible, entries and dates have been verified against available source material on the artist, particularly as revealed by the *Letters of Juan Gris*. Some minor changes in Mr. Cooper's phrasing have been made in the interests of economy of space. And a few entries have been significantly altered, where they did not seem to correspond with existing information in the published Gris *Letters*. All the paintings listed as examples of Gris' stylistic changes have been taken from the Museum's exhibition.

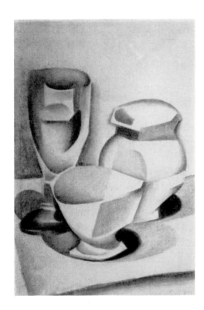 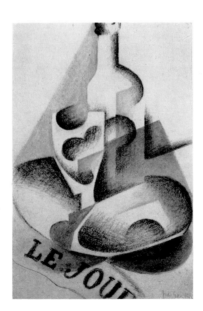 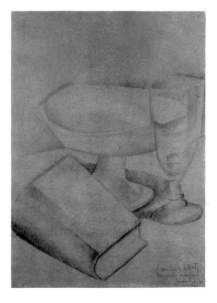

left: *Still Life*. 1916. Crayon, 17⅛ × 11″. Rijksmuseum Kröller-Müller, Otterlo. center: *Still Life*. 1916. Crayon, 17⅞ × 11⅝″. Rijksmuseum Kröller-Müller, Otterlo. right: *Still Life with Book and Wine Glass*. 1916(?). Pencil, 16¼ × 12″. Hanover Gallery, London

SELECTED BIBLIOGRAPHY

by Bernard Karpel

Owing to the availability of numerous Gris bibliographies, some of which are noted below (bibl. 32, 35, 36, 37, 39, 47, 48, 56, 60, 64, 67), it seems advisable to append to the present catalogue only a selective list. The researcher is referred to the thorough documentation in Kahnweiler's monograph (bibl. 36), and its modification, by Hannah Muller, formerly Assistant Librarian, in the English edition (bibl. 37). A comprehensive checklist of Gris references is now on deposit in the files of the Museum of Modern Art Library.

Writings by Gris

1 Des possibilités de la peinture. *Transatlantic Review* 1 no. 6: 482–486, 2 no. 1: 75–79 June-July 1924.
 English translation, bibl. 5.

2 Notes sur ma peinture. *Der Querschnitt* 3 no. 1–2: 77–78 Summer 1923.
 Addressed to Carl Einstein.

3 Réponse à une enquête sur le cubisme. *Documents* 2: 268, 275. 1930.

4 Système esthétique . . . *Esprit Nouveau* no. 5: 534 Feb. 1921.
 Two statements on 'son système esthétique' and 'sa méthode,' supposedly by 'Vauvrecy' (Ozenfant).

5 On the possibilities of painting. *Horizon* 14 no. 80: 113–122 Aug. 1946.
 First publication in English (from bibl. 6) by Douglas Cooper.

6 Les écrits de Juan Gris, p. 274–292. *In* Kahnweiler. Juan Gris. 1946 (bibl. 36).
 Eight items from Valori Plastici *(Feb.-Mar. 1919),* Action *(no. 3, 1920),* L'Esprit Nouveau *(no. 5, 1921),* Der Querschnitt *(no. 1-2, 1923),* Transatlantic Review *(1 no. 6, 2 no. 1, 1924),* Bulletin de la Vie Artistique *(no. 1, Jan., 1925),* Documents *(no. 5, 1930),* Anthologie de la Peinture Française *(Raynal, 1927). Parts I–VIII, translated by Douglas Cooper (bibl. 37), p. 137–146.*

7 [Unpublished letter to Kahnweiler, Dec. 14, 1915.] *Art News* 48 no. 10: 18 Feb. 1950.
 Also note bibl. 45, 64.

8 Letters of Juan Gris, 1913–1927. Collected by Daniel-Henry Kahnweiler; translated and edited by Douglas Cooper. 221 p. London, Privately printed, 1956.
 300 numbered copies for sale; printed for Douglas Cooper.

N.B. For variants (partial publication, translations, etc.) see detailed notes in Kahnweiler's monograph, *both* French and English editions (bibl. 36, 37).

Illustrated Books

9 REVERDY, PIERRE. Poèmes en Prose. Paris, P. Birault, 1915.

9a REVERDY, PIERRE. La Guitare Endormie. Paris, Editions Nord-Sud, 1919.
 Only 'exemplaires de têtes' are illustrated.

10 JACOB, MAX. Ne Coupez pas Mademoiselle ou les Erreurs des P.T.T. Paris, Galerie Simon, 1921.

10a SALACROU, ARMAND. Le Casseur d'Assiettes. Paris, Galerie Simon, 1924.

11 TZARA, TRISTAN. Mouchoir de Nuages. Paris, Galerie Simon, 1925.

12 RADIGUET, RAYMOND. Denise. Paris, Galerie Simon, 1926.

left: Drawing for illustration in *L'Assiette au Beurre*, Jan. 1, 1910, p. 1480. (Not in exhibition.) right: Drawing for illustration in *L'Assiette au Beurre*, Oct. 24, 1908, p. 491. Crayon with gouache, $14\frac{1}{4} \times 11\frac{1}{8}''$. Collection Mr. and Mrs. David Rockefeller, New York.

13 STEIN, GERTRUDE. A Book Concluding With As A Wife Has A Cow A Love Story. Paris, Galerie Simon, 1926.

N.B. For technical details of edition see Kahnweiler (bibl. 36, p. 293–295), who lists graphics and books reproducing Gris drawings, also referring to drawings contributed to *Madrid Comico, Blanco y Negro, L'Assiette au Beurre, Le Cri de Paris, Le Charivari*, and *Le Témoin*.

Books about Gris

14 APOLLINAIRE, GUILLAUME. Anecdotiques. p. 60–61. Paris, Stock, 1926.

15 APOLLINAIRE, GUILLAUME. The Cubist Painters – Aesthetic Meditations, 1913. p. 41–43. New York, Wittenborn, Schultz, 1949.
Bibliography on Apollinaire and cubism, p. 54–64.

16 AZNAR, JOSÉ CAMON. Picasso y el Cubismo. p. 177–252. Madrid, Espasa-Calpe, 1956.

17 BARR, ALFRED H., JR. Cubism and Abstract Art. p. 29, 42, 48, 77, 82–84, 211, 244–245 ill. New York, Museum of Modern Art, 1936.

18 BILLE, EJLER, Picasso, Surrealisme, Abstrakt Kunst. p. 75–77 ill. Copenhagen, Helios, 1945.

19 BULLIET, CLARENCE J. The Significant Moderns and Their Pictures. p. 142–143 ill. New York, Covici-Friede, 1936.

20 COOPER, DOUGLAS. Juan Gris, ou le Goût Solennel. [14] p. plus 15 col. pl. Geneva, Skira, 1949.

21 DORIVAL, BERNARD. Les Étapes de la Peinture Française Contemporaine. v. 2, p. 246–252. Paris, Gallimard, 1944.
Supplemented by his: Les Peintres du Vingtième Siècle. p. 77, 84, 86, 96, 118, 119, 129–30 ill. Paris, Tisné, 1957.

22 EINSTEIN, CARL. Die Kunst des 20. Jahrhunderts. p. 103–106, 368, 383, 639. Berlin, Propyläen, 1931.
Also in first (1926) and second edition (1928).

23 ESCHOLIER, RAYMOND. La Peinture Française du XXe Siècle. p. 82–83 ill. Paris, Floury, 1937.

24 FRANCASTEL, PIERRE. Histoire de la Peinture Française, II; Du Classicisme au Cubisme. p. 131–151 (passim), 191. Paris, Brussels, Elsevier, 1955.
Extensive biographical note by M. Bex.

24a GALLATIN, A. E., COLLECTION. A. E. Gallatin Collection, "Museum of Living Art," p. 36–37. Philadelphia, Philadelphia Museum of Art, 1954.

25 GAUTIER, MAXIMILIEN. Gris. *In* Edouard-Joseph, R., ed. Dictionnaire Biographique des Artistes Contemporains, p. 149–150 ill. Paris, Art & Edition, 1931.

26 GEORGE, WALDEMAR. Juan Gris. 63 p. ill. Paris, Gallimard, 1931.

27 GEORGES-MICHEL, MICHEL. From Renoir to Picasso. p. 98–99. Boston, Houghton Mifflin, 1957.

28 GLEIZES, ALBERT and METZINGER, JEAN. Cubism. 133 p. ill. London, Unwin, 1913.

29 GULLON, RICARDO, De Goya al Arte Abstracto. p. 99–111 ill. Madrid, Cultura Hispanica, 1952.

30 HAFTMANN, WERNER. Malerei im 20. Jahrhundert. ill. Munich, Prestel, 1954–55.
Vol. I: p. 215–219, 500. – II: p. 112, 127–131.

30a HENRY, DANIEL. See KAHNWEILER.

31 HILDEBRANDT, HANS. Die Kunst des 19 und 20 Jahrhunderts. p. 392–393, 395 ill. Wildpark-Potsdam, Athenaion, 1924.

32 HUYGHE, RENÉ, ed. Histoire de l'Art Contemporaine: la Peinture. p. 227–231 et passim. Paris, Alcan, 1935.
Includes chapter by Cassou and bibliography by Bazin from L'Amour de l'Art, Nov. 1933.

33 JANNEAU, GUILLAUME, L'Art Cubiste, pl. 7, 10, 19, 20, 45. Paris, Moreau, 1929.

34 JARDOT, MAURICE and MARTIN, KURT. Die Meister französische Malerei der Gegenwart, p. 48, 53 ill. col. pl. Baden-Baden, Klein, 1948.
Includes text by Kahnweiler.

35 KAHNWEILER, DANIEL-HENRY. Juan Gris [by Daniel Henry, pseud.]. 16 p. 32 ill. Leipzig & Berlin, Klinkhardt & Biermann, 1929.
Junge Kunst, bd. 55. Bibliography.

36 KAHNWEILER, DANIEL-HENRY. Juan Gris: sa Vie, son Oeuvre, ses Écrits. 3 ed. 344 p. ill (col. pl.). Paris, Gallimard, 1946.
Part I: La vie. – II: L'oeuvre. – III: Les écrits. – Bibliographie, p. 312–326. Expositions, p. 296–309.

37 KAHNWEILER, DANIEL-HENRY. Juan Gris, His Life and Work. Translated by Douglas Cooper. 178 p., 171 ill. (col. pl.). London, Lund Humphries; New York, Curt Valentin, 1947.
"It has been necessary . . . to adapt and add to the text of the French edition." (D.C.) Bibliography by H. B. Muller (103 items).

38 LAKE, CARLTON and MAILLARD, ROBERT. A Dictionary of Modern Painting. p. 115–118 ill. New York, Tudor, 1956.
Translated from French edition (Hazan, Paris).

39 LASSAIGNE, JACQUES. Spanish Painting from Velásquez to Picasso. p. 127, 138, 146 et passim. Geneva, Skira, 1952.
Biographical and bibliographical note.

40 LORD, DOUGLAS [pseud. of Douglas Cooper]. Modern Art and Tradition. *In* A. C. Johnson, ed. Growing Opinions. London, Methuen, 1934.

41 MARCHIORI, GIUSEPPE. Pittura Moderna in Europa. p. 123–127 ill. Venice, Pozza, 1950.

42 MILLER COMPANY (Meriden, Conn.). Painting Toward Architecture. p. 58–59 et passim, col. pl. New York, Duell, Sloane, 1948.
An abstract collection; general text by Henry-Russell Hitchcock; comment by M. C. Rathbun.

43 OZENFANT, AMÉDÉE. Foundations of Modern Art. p. 104–106 ill. New York, Brewer, Warren & Putnam, 1931.
Other editions: N.Y., Dover, 1952. Original title: Art *(Paris, Budry, 1929).*

44 POWER, J. W. Eléments de la Construction Picturale, p. 53, 88–96 ill. Paris, Roche, 1932.

45 PRISME (Periodical). Panorama de l'Art Présent. p. 22–24 ill. Paris, Éditions d'Art et Industrie [1957].
Includes article by Kahnweiler from no. 3, May 15, 1956: "Une lettre inédite de Juan Gris," dealing with Ozenfant and Gris.

46 RAYNAL, MAURICE. Juan Gris. 12 p. plus 20 mounted plates. Paris, L'Effort Moderne, 1920.
Reprinted Bulletin de l'Effort Moderne, *no. 16: 1–16 June 1925.*

47 RAYNAL, MAURICE. Modern French Painters. p. 93–100 ill. New York, Brentano's, 1928.
French edition 1927. Includes Gris texts and bibliography.

48 RAYNAL, MAURICE (and others). History of Modern Painting, [Vol. III]: From Picasso to Surrealism. p. 66–68, 132–133, 196 et passim. Geneva, Skira, 1950.
Biographical and bibliographical notes. Revised single vol. edition: Modern Painting *(1953, etc.).*

49 SALMON, ANDRÉ. L'Art Vivant. p. 139–142. Paris, Crès, 1920.

50 SALMON, ANDRÉ. La Jeune Peinture Française. p. 57. Paris, Messein, 1912.

51 STEIN, GERTRUDE. The Autobiography of Alice B. Toklas. passim, ill. New York, Harcourt Brace, 1933.

52 STEIN, GERTRUDE. Portraits and Prayers. p. 46–47. New York, Random House, 1934.
Partly reprinted: Lectures in America. p. 82 (1935).

53 STERUP-HANSEN, DAN, ed. Juan Gris: Et Foredrag, 23 p. ill. Copenhagen, Wivel, 1946.

54 THARRATS, JUAN-JOSÉ. Artistas Españoles en el Ballet. p. 15–26 ill. Barcelona, Buenos Aires, Argos, 1950.

55 TORRES-GARCIA, JOAQUIN. Universalismo Constructivo. p. 513–520. Buenos Aires, Poseidon, 1944.

56 VOLLMER, HANS. Allgemeines Lexikon der Bildenden Künstler des XX. Jahrhunderts. Vol. 2, p. 311–312. Leipzig, Seemann, 1955.
Biographical and extensive bibliographical notes.

57 WILENSKI, REGINALD H. Modern French Painters. passim. Glasgow, University Press; New York, Harcourt Brace, 1954.
Other editions: 1940, 1944, 1949.

58 ZERVOS, CHRISTIAN. Histoire de l'Art Contemporaine. p. 236–240, 287–296, 304 ill. Paris, Cahiers d'Art, 1938.

Catalogues

59 PARIS. GALERIE SIMON. Exposition Juan Gris. 8 p. ill. Mar. 20–Apr. 5, 1923.
Introduction by M. Raynal; 54 works (1911–1923) plus drawings and lithographs. Also "Exposition in memoriam Juan Gris," June 1928.

60 BERLIN. GALERIE FLECHTHEIM. In memoriam Juan Gris, 1887–1927. 14 p. ill. Feb. 1930.
Includes G. Stein: Leben und Tod des Juan Gris (from Transition). Biography and bibliography; list of 90 works.

61 ZURICH. KUNSTHAUS. Juan Gris. [40] p. ill. Apr. 2–26, 1933.
Special number of Cahiers d'Art *(bibl. 100) issued with special cover (Juan Gris, du 2 au 26 Avril – Fernand Léger, du 30 Avril au 25 Mai); also insert of the Museum's catalogue. Preface by W. Wartmann; list of 147 works.*

62 PARIS. GALERIE BALAŸ & CARRÉ. Juan Gris, Exposition, 12 p. 23 pl. June 13–July 3, 1938.
Texts: "Juan Gris" (M. Raynal). – "The life and death of Juan Gris" (G. Stein). – "Notice biographique" (D. Lord). – Catalogue (23 works, 1911–1920).

63 NEW YORK. SELIGMANN & CO. Retrospective Loan Exhibition: Juan Gris. Nov. 10–Dec. 1938.
Texts by Gris, Raynal and Stein; lists 27 works.

64 NEW YORK. BUCHHOLZ GALLERY (Curt Valentin). *Juan Gris.* Mar. 28–Apr. 22, 1944. – Apr. 1–26, 1947. – Jan. 16–Feb. 1, 1950.
1944: Preface by J. Lipchitz; text by Gris (1926); bibliography; 40 works. – 1947: Text by Gris; 27 exhibits. – 1950: Gris letter to Kahnweiler (with facsimile); 46 exhibits.

65 CINCINNATI MODERN ART SOCIETY. Juan Gris, 1887–1927. 16 p. ill. Apr. 30–May 31, 1948.
Held at the Art Museum, Cincinnati; preface by E. H. Dwight; 64 works.

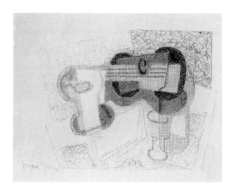

Still Life with Guitar. c. 1923. Ink, $8\frac{1}{2} \times 11\frac{1}{2}''$.
Collection Clifford Odets, Beverly Hills, Calif.

66 SAN FRANCISCO. MUSEUM OF ART. Picasso, Gris, Miro: the Spanish Masters of Twentieth Century Painting. 108 p. ill. 1948.
Nos. 21–41 by Gris exhibited Sept. 14–Oct. 17; at Portland Oct. 26–Nov. 28. Texts by R. B. Freeman, D. Gallup, D.-H. Kahnweiler, Gris, etc.

67 BERNE. KUNSTMUSEUM. Juan Gris. 2 Aufl. 80 p. ill. Oct. 29, 1955–Jan. 2, 1956.
Foreword and catalogue by D. Cooper; bibliography and chronology; 187 exhibits.

68 VENICE. ESPOSIZIONE BIENNALE. Catalogo. p. 250–255 ill. Venice, Alfieri, 1956.
28th biennial; lists 29 works; text by Kahnweiler.

68a PARIS. GALERIE LEIRIS. L'Atelier de Juan Gris. 26 p. ill. Oct. 23–Nov. 23, 1957.
Preface by Kahnweiler, 22 paintings (1926–1927); all illustrated (9 col. pl.). Reviewed l'Oeil Jan. 1958.

Articles

69 ADAMS, PHILIP R. The ill-starred troubador of cubism. *Art News* 47: 44–45, 55–56 ill. May 1948.
On the occasion of the "first show in a U.S. museum" (bibl. 65).

70 BRUGUIÈRE, P. G. La présence de Juan Gris. *Cahiers d'Art* 26: 115–136 ill. 1951.

70a CAHIERS D'ART. Vol. 8, 1933. *See* bibl. 61, 100.

71 CAILLOIS, RONALD P. Le cubisme classique de Juan Gris. *Critique* 2 no. 12: 411–416, 1947.
"Compte-rendu du livre de M. Kahnweiler," 1946.

72 CASANYER, M. A. Juan Gris. *D'Aci i D'Ala* 22: 16–17 ill. Dec. 1934.

73 CHAMBERLAIN, J. B. "Still-life with Guitar" acquired by St. Louis. *St. Louis Museum Bulletin* 25: 21–24 ill. Apr. 1940.
Also note: Juan Gris' "Still Life." Minneapolis Institute of Art Bulletin 42 no. 21: [1–3] May 23, 1953.

74 CLARKE, ELIOT. Milestones in modern art: 1. Guitar and Flowers by Juan Gris. *The Studio* 153 no. 770: 136, 153 col. ill. May 1957.

75 DAVIDSON, MARTHA. Juan Gris, a pivotal figure of the school of Paris. *Art News* 37: 13–14. Nov. 26, 1938.

76 EINSTEIN, CARL. Juan Gris: texte inédit. *Documents* 2: 267–268 ill. 1930.
Also "Exposition Juan Gris, Berlin," 2: 243–248 ill. 1930.

77 ELGAR, FRANK. Une conquête du cubisme: le papier collé. *XXe Siècle* no. 6: 3–17 ill. Jan. 1956.

78 GEORGE, WALDEMAR, Juan Gris. *L'Amour de l'Art* 2 no. 11: 351–352 ill. Nov. 1921.

79 GOLDING, JOHN. Juan Gris at Berne. *Burlington Magazine* 97: 384–386 ill. Dec. 1955.

80 Ha mort Juan Gris. *Amic de les Arts* (Sitges) 2: 40. May 31, 1927.

81 J., J. Juan Gris. ill. *La Publicidad* (*Barcelona*) Apr. 4, 1912.

82 JUDKINS, WINTHROP. Toward a reinterpretation of cubism. *Art Bulletin* 30: 270–278 ill. Dec. 1948.

83 KAHNWEILER, DANIEL-HENRY. Cubism: the creative years. *Art News* 53 no. 7, pt. 2: 106–116, 180–181 ill. Nov. 1954. *The Art News Annual, v. 24 (1955), Nov. 1954, part II.*

84 KAHNWEILER, DANIEL-HENRY. Der Tod des Juan Gris. *Der Querschnitt* 7: 558, July 1927.

85 L., H. A., A note on Juan Gris and cubism. *Broom* (*New York*) 5: 32–35 ill. 1923.

85a LITTLE REVIEW. *See* STEIN.

86 LORD, DOUGLAS [pseud. of Douglas Cooper]. Juan Gris. *Axis* no. 7: 9–12 ill. Autumn 1936.

87 NICHOLSON, BENEDICT. Cubism and Juan Gris. *Horizon* 17 no. 99: 225–227 Mar. 1948. *A review of Kahnweiler, 1947 (bibl. 37). Cf. bibl. 71.*

88 PAUL ELLIOT. A master of plastic relations. *Transition* no. 4: 163–165 July 1927.

89 RAYNAL, MAURICE. Juan Gris. *L'Esprit Nouveau* no. 5: 531–554 ill. Feb. 1921.

90 RAYNAL, MAURICE. Juan Gris et la métaphore plastique. *Feuilles Libres* 5: 63–65, Mar.–Apr. 1923.

91 RAYNAL, MAURICE. Juan Gris. *Bulletin de l'Effort Moderne* no. 16: 1–16 June 1925. *Supplemented by: La mort de Juan Gris. Art Vivant 3: 431–432 June 1, 1927. – June Gris vu par Maurice Raynal [by J. V. Helot]. Beaux Arts 75: 6 July 2, 1938.*

92 SELIGMANN, E. G. and G. Of the proximity of death and its stylistic activations: Roger de la Fresnaye and Juan Gris. *Art Quarterly* 12 no. 2: 146–155 ill. 1949.

93 STEIN, GERTRUDE. Juan Gris. *The Little Review* 10 no. 2: 16 ill. Autumn 1924–Winter 1925. *Reproduces Man Ray portrait of and 17 works by Gris.*

94 STEIN, GERTRUDE. The life and death of Juan Gris. *Transition* no. 4; 159–162 July 1927.

95 TÉRIADE, E. Juan Gris. *Cahiers d'Art* 3: 231–235 ill. 1928. *Illustrated. p. 236–246.*

96 VENTURI, LIONELLO. Piero della Francesca – Seurat – Gris. *Diogenes* (*Brooklyn*) no. 2: 19–23. Spring 1953.

97 VÉZELAY, P. Juan Gris. *Artwork* (*London*) 4: 258–261 ill. Winter 1928.

98 WARNOD, ANDRÉ L.'esthétique de Juan Gris. *Comoedia* (*Paris*). Mar. 17, 1923. *Also "Juan Gris," May 13, 1927.*

99 ZERVOS, CHRISTIAN. Juan Gris et l'inquiétude d'aujourd'hui. *Cahiers d'Art* 1: 269–274 ill. 1926. *Also "Juan Gris," 2: p. 170, 1927, and "Quelques notes de Juan Gris sur ses recherches," 2: 171, 1927.*

100 ZERVOS, CHRISTIAN, ed. Juan Gris. *Cahiers d'Art* 8: 178–208, 72 ill. 1933. *Special number, Gris-Léger, also issued for Zurich exhibition (bibl. 61). Texts by the editor, Apollinaire, Salmon, Ozenfant, Daniel-Henry [Kahnweiler], Raynal, Gris.*

Color Reproductions

In addition to bibl. 20, 68a and other references, a few suggestions are noted below for convenience in locating and studying typical color plates.

Dix Reproductions. Paris, Bucher; New York, Becker, 1933. – *Dorival, B. Contemporary French Painting.* Paris, Nomis, n.d. & *Peintures du Vingtième Siècle.* Paris, Tisné, 1957. – *Eluard, P. Voir.* Geneva, Paris, Trois Collines, 1948. – *Einstein, C. Kunst der XX. Jahrhundert.* Berlin, Propyläen, 1926, 1928, 1931. – *Haftmann, W. Malerei im. 20 Jahrhundert.* v.2, p. 130. Munich, Prestel, 1955. – *Huyghe, R. Les Contemporains.* Paris, Tisné, 1949. – *Lassaigne, J. Spanish Painting.* Geneva, Skira, 1952. – *Miller Company. Painting Toward Architecture.* N.Y., Duell Sloan & Pearce, 1948. – *Raynal, M. Peintres du XXe Siècle.* Geneva, Skira, 1947. – *Schmidt, P. F. Geschichte der Modernen Malerei.* Zürich, Fretz & Wasmuth, 1952. – *Stein, G. Paris France.* London, Batsford, 1940.

Art d'Aujourd'hui. no. 3-4, May-June 1953. – *Art News.* no. 3, p. 45 May 1948. – no. 10, p. 19 Feb. 1950. – no. 7, part II (1955 Annual), p. 106 Nov. 1954. – *Du.* p. 36 Nov. 1949; p. 31 Jan 1952. – *Oeil.* no. 22, p. 40 Oct. 1956. – *Studio.* no. 770, p. 137 May 1957. – *XXe Siècle.* no. 2, facing p. 16 Jan. 1952.

INDEX